Yantra - An Encyclopedia

A complete guide to Yantra making
and its miraculous benefits

Sushma Johari Madan

For my dear Maa and Baoji

& My dada, my guardian angel, Harish Johari.

And my dear friends and family

Nothing is possible without a team of supporters who believe in you. I would like to thank my dear husband for encouraging me, supporting me and guiding me throughout.

I would also like to thank my beautiful daughters, my extended family and my students who showed immense faith in me.

Finally, I would like to say a special thanks to my youngest daughter Sona and my eldest grandson Paavan for their relentless effort in getting this book published.

Thank you!

Contents

Preface

Dear Readers, my name is Sushma Johari Madan and my students fondly call me Sushma Maa.

Since I was young, I have observed and worshipped images of Yantra as part of the religious rituals in my family's daily routines and also more importantly when there was a crisis or celebration of any type.

It was, however, relatively recently that I have fully appreciated the benefits of Yantra making and registered how it's presence in my early life worked favourably for me.

A lot of you may have also seen an image of a Yantra and some of you perhaps even have an image in a temple or place of worship at your home.

Not many, however, understand what a Yantra does and why it is considered to be auspicious and magical.

In the recent years, my work has been focussed on spreading this awareness. I strongly believe that when you understand and appreciate the logic behind any subject, you tend to embrace it more wholeheartedly.

In this book I will tell you what is a Yantra, where it originates from, why it is so powerful, how it can enhance your life and give you step by step direction on how to make one. I am hence taking the liberty of calling this book series, an encyclopaedia – a one-stop shop for everything related to Yantras.

Let's begin firstly with the word 'Yantra'.

The literal translation of the word Yantra in Hindi language is "machine/mechanism" or "tool".

In engineering terms, a machine is any device that processes an input into an output that has the purpose to aid human effort and improve the quality of human life.

Similarly, a Yantra is also a device which creates an energy and makes it easier for humans to achieve things that seem otherwise impossible to achieve.

As humans we all seek answer to one universal question.

What is the purpose of our birth?

We usually look for answer to this question from the outside world as if someone out there knows and we just need to find the right person who will give us that answer.

Some experts out there even claim they know the answer and we follow them naively in anticipation which is later followed by disappointment.

The truth is, the answer to all our questions lies within us. We just need to know how to let the answer surface and become visible.

Seems near impossible right?

Yantra making is the tool that helps us with self-realisation and self-awareness, that leads us to all the answers we seek.

Yantra making is also known as a sacred art. Various types of Yantras are placed in temples and other places of worship and a number of people even place these in their homes.

Whilst the visual image is commonly seen by all, seldom people understand the power of Yantra or how and why that power can help us.

Yantra is a powerful and practical tool, that can change our life. I am writing this book to explain the important aspects of Yantra in simple words and give you all the tools you need to make a Yantra and benefit from this incredible art.

Miraculous Benefits of Yantra Making

Life is a gift. Each and every moment we live is a moment that cannot be lived again so we need to ensure that we spend our precious time and energy on things that add value.

Before you embark on making a Yantra, I urge you to read this chapter to understand about some of the benefits of Yantra making.

The process of Yantra making increases the functionality and effectiveness of our brain.

Our brain is like the head office of our body. This is where we make important decisions of our life and send instructions to the rest of our body. This organ also controls our moods and emotions.

I am sure you will agree that this is probably the most important organ of our body.

We all take a lot of actions to make our body healthier because we know the importance of being fit and healthy. Some examples of these activities are putting oil or masks on our hair or moisturising our skin or eating foods that are good for our heart.

Now think what actions you actively take to make your brain healthier? Probably not many and definitely not enough!

Our mental health is vital to our overall wellbeing. Thankfully the whole world is becoming more aware of this. But do we know enough

about how to make our mental health better and how to make our brain healthier?

Compared to when I was young, society has become much more health conscious, which I believe is an improvement since people are giving much more importance to their health and fitness which is resulting in better quality of life.

Despite how busy and hectic modern-day life has become, people still make time to exercise regularly. There has especially been an increase in the popularity of gyms, with many offices even providing such facilities.

Many exercises for the brain also exist. Some even have mobile apps to make it more convenient for us. Examples of these include puzzles and sudokus, which are excellent for developing our mental capacity and efficiency, as well as, keeping the brain's cognitive functions intact for longer.

These exercises are great and very useful however they are not nearly enough for our brain.

To understand this, we need to understand a little more about the brain first.

One way to separate the brain is into three sections that are responsible for the human being's unique ability to navigate the world. The lower brain consists of the primitive reptilian brain and the R-complex, these are responsible for our impulses and our most basic survival functions. Above this is the limbic system which is responsible for our emotional responses and behaviours. The upper brain consists of the neo cortex which is responsible for higher order brain functions such as abstract thinking, perception, cognition and reasoning. The upper brain consists of two hemispheres, the left and right

Both hemispheres have unique attributes and different purposes in the function of the mind and body.

The left hemisphere is responsible for control over the right side of our body and performing analytical and logical cognitive functions such as mathematics, speech and language. Whereas, the right hemisphere is responsible for control over the left side of our body and performing creative cognitive functions which may involve pattern processing such as art and music.

We tend to develop a more persistent use of a particular hemisphere from an early age. This has an influence on developing our personality and thought process.

According to astrology the left brain is logical and ruled by Mercury and the right brain is intuitive and ruled by Jupiter.

Activities such as games and puzzle exercises only activate the left hemisphere of the brain, the analytical and calculative side.

Other activities such as playing a musical instrument, dancing or colouring in are also excellent brain exercises that help improve our mental health and processing power, however they only activate the other hemisphere of your brain, the creative and intuitive side.

Both hemispheres have extraordinary and unique qualities but have you considered what would happen if we simultaneously combine the qualities of both hemispheres?

Logic with intuition and intuition with logic. If we are able to do this then we would begin to think like an enlightened person.

The process of making a Yantra is unique in that it trains both hemispheres of our upper brain to work together which is why it is believed that this is an important activity for our brain.

The process of making a Yantra is designed as such to exercise both hemispheres of our brain at the same time. Our mind is active in doing both precise calculations and aesthetic artwork at the same time in order

to create beautiful yet precise geometry and shapes. Yantra destresses us and provides balance to our brain.

The left hemisphere of the brain is responsible for the 'known' and order whereas the right hemisphere is engaged in novelty and the 'unknown', so union of the two hemispheres through Yantra making can also help with solving problems as the brain is engaged in exploring a problem to which the solution is unknown, engaging the right hemisphere's exploratory nature, by using what is known, engaging the left hemisphere.

It is very easy to forget that even if our limbs do not work properly but we have a healthy brain we are still able to live gracefully. However, if we consider the opposite where our body may be fully functional however our brain does not work properly then life becomes dysfunctional.

Even the gift of life becomes a waste. Thus, our brain's fitness should be our upmost priority.

Along with the advancement of technology such as smart phones and calculators, with the sole purpose of making our lives easier. They are also making our brains dependant on such technology, as we no longer exercise our brains by memorising phone numbers or performing difficult calculations.

Ultimately this leads to the neurons in our brains to become inactive and thus decreases our mental capacity. Slowly we face problems, particularly to do with our memory. Alzheimer is one such neurodegenerative disease which is related to the brain functionality deteriorating over time and with age.

Another way to look at the same thing is that the left brain is masculine and the right brain is feminine, symbolically. It is important to note that here masculine and feminine (eternal symbolisms) are separate from male and female (biological).

The function of the hemispheres is highlighted by the illustration on the side.

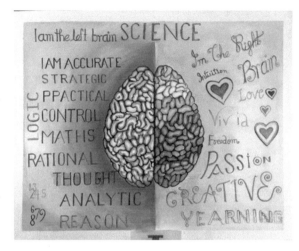

When I ask my students how they make decisions about a particular situation in their day to day lives. Some students respond by saying they take decisions with their heart whilst others respond that they take decisions with their mind.

It is easy to forget that the heart is an organ with the purpose of pumping blood. It has no capacity to think.

However, since the heart has become a very popular metaphor for what is scientifically the right hemisphere of the brain so I also do sometimes use this term and refer to some people as being heart-orientated and others being mind-orientated.

The hemispheres are useful in different situations however the problem arises when you start to compare.

In the same situation, when faced with a decision, two different individuals will find it very difficult to understand each other's point of view if the opposite hemispheres of their brain are more dominant.

An example of this could be a situation where a couple is considering whether to buy a pet, the heart-oriented person would see it as getting a companion to give affection to and be able to play with and relieve stress, however a mind-oriented person would be very mindful of the responsibility it brings and all the financial implications. Neither of them will be wrong, but they look at the same situation with opposite perspectives.

This can often lead to arguments and frequently cause frustrations to build.

One of the main causes of marital drifts such as separation or divorce is this, that partners fail to understand each other's point of view.

Since left brain orientated and right brain orientated thought processes are different, they also have different points of view which can lead to people misunderstanding and being unable to comprehend each other's feelings. In a specific situation a left brain orientated person may see someone making a decision with their right brain as an 'emotional fool', whereas, right brain orientated person may see someone making a decision with their left brain as if they are 'cold hearted' or being too practical.

These same people may in a completely different situation use the other hemisphere of their brain, this is determined by their personality.

However, every individual does have a natural tendency or inclination to use a particular hemisphere that is more dominant more often.

The problem is that from an early age human tend to develop a more persistent use of a particular hemisphere which has an influence on the individual's personality.

This can be seen in children, where some kids tend to be more emotional and empathetic since their right hemisphere plays a more dominant role in their personality, these children tend to have a greater imagination and excel at creative tasks.

On the other hand, some children are more practical and logical as their left hemisphere is more active in their personality, these children tend to be better at reasoning, analytical and comprehension tasks.

The degree to which a particular brain hemisphere is more active and plays a more dominant role in an individual's personality varies between

people and is impacted by the environment they are in and changes depending on the situation the individual faces.

Although people can change over time, it is very difficult for anyone to actually change their own nature and thought process at any stage throughout their life. This is because at that time they do not realise they need to make any changes.

At the end of their lives a lot of people have regrets about their decisions and the way they lived their lives. Very often these regrets are caused by their nature and way of thinking which they have possessed at the time they made a certain decision.

By the time most people realise this, it is seldom too late.

However, some people do manage to have a broader vision and are able to make changes or see and respect a perspective different to theirs in time. We tend to call these people 'enlightened'.

The difference between a normal and an enlightened person is that normal people can only think, feel and make a decision using one part of their brain whereas an enlightened person has both their brain hemispheres work simultaneously in every thought and decision they have and make.

Both hemispheres work together to allow an enlightened person to see all aspects and make the decision with clarity and come up with balanced solutions. This results in the power and foresight to take the correct decisions.

I strongly believe that if children are taught Yantra making at least once a week from a young age we will realise and observe that children will develop a more balanced thought process.

Some of my very young students have observed a significant improvement in their academic performance and capacity to learn at school through regularly practicing Yantra making.

Through integrating both empathy (heart) and logic (mind), it will allow them to make better decisions in their day to day lives and solve many problems.

Since both thought processes and emotions are balanced within oneself. We would be able to take the right decision in every aspect of our lives, be it business, career, family, relationships, finances and personal or emotional struggles etc.

We would attain the ability to recognise both the emotional and practical solutions and thus have the vision to make the right decision by being aware of all aspects of any situation we are in.

If we go back to the example of the couple who had the dilemma of whether to get a pet or not, maybe if any unnecessary expenses are cut then the pet can be financed more easily and if responsibilities are delegated equally amongst family members, then the benefit and joy of owning the pet can be enjoyed emotionally, practically and financially.

There are various other everyday situations where we can find a solution

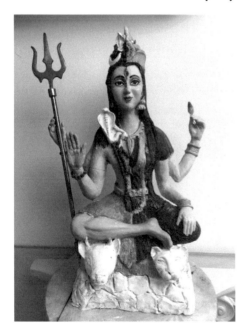

or a middle ground and avoid frustration levels from building up.

A single point of view can often lead to a misguided solution and hence multiple perspectives can actually be beneficial all round and lead to a more balanced and harmonious answer.

Ardhanarishwer, the form of half Shiva and half Shakti is a physical representation of this.

Shakti represents the feminine energy, which is also the right brain.

Shiva represents the masculine consciousness, which is the left brain.

Combining both creates the divine harmony!

The Yantra making procedure is the best and probably the only exercise for simultaneous use of both sides of the brain.

It is important to note that Yantra making is not a one-off activity. Completing one Yantra is not enough to enable balanced use of the brain.

This is a process which requires a lot of practice at Yantra making to receive all the benefits. It's similar to healthy eating. Just eating one healthy meal will not give you a lifetime of good health. It is something we need to make part of our lifestyle to ensure long term benefits.

If we wish to optimise and balance the use of both hemispheres of the brain then we need to make a Yantra as regularly as we can.

Ideally, we should practice Yantra making every day to balance both of the hemispheres of our upper brain.

I like to think of Yantra as a gym for our brain.

Yantra Making as a Tool for Relaxation and Meditation

There is no power in this world which has as profound of an impact as meditation does on the human mind.

Through meditation we attempt to silence our mind. This is how we relax our body and our mind and improve our ability to focus. And focus, is what helps us achieve success and turn our ideas or dreams into reality.

However, this a catch 22 situation. We know the importance of relaxing and silencing the mind but to silence the mind we need to be relaxed already.

Our minds are very restless and have a tendency to constantly run with thoughts.

Our thoughts are a result of our mind's memory which gives us thoughts about things we have done and regrets we have from the past. As well as our mind's imagination which makes us think of things we have to do or situations which may or may not happen, in the future.

Both of these result in our thoughts distracting us from the present, from the moment we are actually in.

Through meditation we attempt to silence our mind and direct our consciousness towards the moment we are currently present and alive in.

When we are doing meditation, most often we feel sleepy or despite our body being still, our minds get into a cycle of thoughts.

Real meditation occurs when our mind is fully alert but it is without any thought.

Whilst a lot of techniques exist and some work very effectively, all require effort.

Yantra making procedure can make meditation somewhat easier and automatic!

This is because of how the process is designed.

Yantra making allows people to easily connect and associate with geometrical figures. Constructing a Yantra involves numerous calculations, as well as, small and precise measurements that our brains become involved with.

This gives us no capacity to even think about anything else. It requires our full concentration as well as our minds to be alert otherwise we are unable to make the Yantra.

Meditation is when our consciousness expands and connects our soul with the supreme consciousness, Brahma. Drawing a Yantra makes this automatic. Whether we want to or not, when we start making Yantra we then connect with the energy of the deity of the Yantra.

The Yantra making procedure practices our mind in withdrawing our consciousness from the outer world and takes us directly to the inner world within the framework of our own mind.

It helps us go beyond the normal framework of the mind to an altered state of consciousness.

The procedure keeps our mind both fully alert and conscious yet silences our mind and stops it from being distracted by the outer world. This is the beauty of Yantra making!

Yantra making is an instrument that helps us reach a state known as 'turiya'.

'Turiya' is the stage of deep meditation that master yogis reach and is a special stage of 'Samadhi' (deepest form of meditation).

The Sacred Geometry of Yantras and Mandalas

The almighty has made innumerable beautiful creations including humans, animals, plants, galaxies and planets.

If you look at all of these creations and analyse them, there is something in common.

All the creations appear to have been made using geometric forms with a common underlying blueprint.

A lot of scientific research has been performed and concluded that there is ratio that is common to all creations. This is known as the Golden ratio which is 1.61803398875 (approximated to 1.62). This ratio is often called the most beautiful number in the universe because it creates aesthetically pleasing compositions that draw the eye to the most significant element.

Our learned sages created Yantras on the same ratio to receive divine powers, that's why the art of Yantra making is referred to as a sacred art.

The purpose of sacred art is to connect us with the entire cosmos, thus giving us the opportunity to connect with the energy of every deity, planet and the creator of this universe.

Yantras are often linked to Mandalas.

A Mandala is a symmetrical geometrical pattern that can be used to enclose or encircle the yantra. Mandala making compliments Yantra making.

Mandalas on their own originate from a very old Indian tradition – Rangoli.

In India everyone used to make rangoli in front of their house each and every morning but now things are changing.

Everyone is so busy that now Rangoli making primarily takes place at the time of religious festivals.

Mandalas are slightly different to free hand rangoli as we use Vedic square in making Mandalas.

The Vedic square is an ancient mathematical numbers chart which can be used to make an unlimited number of Mandala patterns.

The centre point of a Mandala is our consciousness and the entire Mandala is the expansion of that consciousness.

Just as there is no one correct method for our consciousness to expand and become one with the supreme consciousness, everyone's journey and union with their consciousness is unique. Mandala is representative of this.

Mandalas are designed in a circle with no beginning nor an end. A circle denotes balance, it has never-ending energy.

Creating the Yantra may not be an easy procedure, however, making the Mandala is a great relaxation exercise.

We are able to design the Mandala in any way we desire and it is a way of expressing our inner self.

We are able to use images from nature, expressions of our thoughts and emotions and express those via art work.

The Mandala is a reflection of our personality and provides balance and perfection to our lives.

Mandala is a means through which we are able to satisfy deep and complicated mysteries of our inner world.

By exploring this we can achieve a state of peace and blissfulness that can give us a new perspective on life.

Therefore, the Mandala is an easy form of meditation.

Mandala making also has tremendous healing powers, it has the ability to heal pain, insomnia, stress, depression and anxiety.

The basic rule of making a Mandala is that the centre point should be equidistant from wherever it is measured on the Mandala edge.

The centre point of the Mandala is symbolic of our life energy.

By making a Mandala cosmic energy is able to circulate through our body which connects us with the entire universe. Thus, providing us with harmony and unity which can increase the quality of our life.

Although not compulsory, Mandalas should ideally be constructed around Yantras for it to be even more beneficial.

The energies of the deity or planet that are present from being invoked by the Yantra and the Mandala help keep those energies around us.

Just as around us everywhere there is nature, the Sun, the Moon and other life. Similarly, a Mandala around the Yantra is a reflection of the universe and its creations which possess the energy of planets and deities.

By creating Mandalas specific to us, according to our personal numerology (psychic and destiny numbers), we are able to channel the energy of the Yantra to work specifically for us.

Yantra as a way of Spirituality

Yantra in Sanskrit:

Yam = Death, the name of the God of death

Tra = freedom and liberation, Moksha

Therefore, the meaning of Yantra in Sanskrit is freedom from the fear of death and the attainment of Moksha.

Spiritually the purpose of Yantra is to recognise that we are all a part of the energy of God and through this practice we can understand and connect ourselves to this higher energy.

Thus, we have the opportunity to understand the purpose of our life through understanding ourselves.

The entire universe is sustained by a one energy known as God. Some of us wish to take blessings from this energy and others wish to become connected to and at one with this energy.

We all have our own ways of doing this.

God exists everywhere, consciousness is everything and within every-thing, everywhere. However, the yantra through its geometry, channels specific energies of the divine consciousness into a specific dwelling place. In simple words, a yantra is a dwelling place of the god.

This is why as we gradually create the Yantra our mind reaches a level of calmness and an aura starts to develop around us.

The Yantra making procedure is a method of invoking that specific deity's or planet's energy to which we can directly connect ourselves.

Yantra is a concrete reality which takes us to the abstract truth. We cannot touch, nor see the energy and vibrations of the Yantras, we can only experience them.

Since the process of making a Yantra connects us to these specific energies we say it takes us towards the abstract truth.

The sacred science behind Yantra making occurs in the invoking of energy. The frequency of the Yantra becomes the frequency of the deity or planet and when this occurs, there is no difference between us and God, God's voice becomes our voice.

In this moment our consciousness can experience *'ahum bhahama' (being one with the god).*

> *'Saara brahmaand mujhme hai aur mai saare brahmaand mein'*
>
> Translation: the universe and we are one, the entire cosmos is the expansion of our consciousness.

Mandalas enable us to keep these energies around us and for this reason Mandalas play a very important role in spirituality.

The word Mandala comes from the characteristic of nature to be all around us. We use this word when referring to nature such as *'Aabha Mandal', 'Tara Mandal', 'Akash Mandal'.*

The shape of the Yantra is a beholder of the energy of the deity, the word Yantra becomes a symbol and every symbol becomes a Yantra.

Every religion acknowledges the significance of symbols, and that is why every religion has its own symbol. Such as the 'Aum', the 'Cross', the 'David's star' and many others.

An essence or aspect of God can be reflected in symbols. However, no symbol, picture or sculpture of God is more powerful than the Yantra. The Yantra represents the complete energy of the God.

Historic significance of Yantras

The Yantra is an archetypal unit. The geometry and shapes existing in the Yantra are older than civilisation itself.

In olden times, sages and monks used to draw the geometric shapes with a stick on the floor.

In the early 18th century, Maharaja Jai Singh II of Jaipur constructed five Jantar Mantar structures in total, in New Delhi, Jaipur, Ujjain, Ma thura and Varanasi. The Jantars (including a structure in shape of Ram Yantra) are used for various astronomical calculations.

The name "Jantar Mantar" is at least 200 years old, finding a mention in an account from 1803. However, the archives of Jaipur State, such as accounts from 1735 and 1737–1738, do not use this as Jantra, which in the spoken language is corrupted to Jantar. The word Jantra is derived from yantra, instrument, while the suffix Mantar is derived from mantrana meaning consult or calculate.

The words Jantar and Mantar (or yantra and mantra) mean calculation instrument.

Over time this art has taken various shapes and forms and has been made on different types of bases such as paper, cloth, pebbles, jewellery and utensils.

The ancient Indian city of *Kashi*, now known as *Varanasi* is the oldest living city in the world. In ancient Indian scriptures it is said that *Kashi* was built by Lord Shiva himself.

The city was originally designed in the shape of a powerful Yantra which allowed those in the city to unite with the cosmic reality.

Even today this city is very special for Hindus and Buddhists alike. Many people wish that after they die, their ashes be sent to and scattered in Varanasi, so that after death they can unite with God and attain Moksha.

Scientific significance of Yantras

Science acknowledges that the entire universe is one energy, which can scientifically be labelled as the singularity that existed before the universe began expanding; and all matter is a result of vibrations.

Yantra is a group of very specific and sacred geometrical shapes. The combination of shapes used create different and various types of energies.

All life has the natural internal desire to connect to and receive the energy of the universe. Through the process of making a Yantra we attain the power to connect with the macrocosm. The concrete reality of the Yantra takes us to the abstract truth of the universe.

Up until a few decades ago, it would have been very difficult to explain how vibrations work to the average person.

However, these days due to a better general working knowledge of physics most people have a good understanding of how vibrations work.

With the advancement of technology such as mobile phones, most people are at least aware of Wi-fi.

I am sure you are aware that if there is no wi-fi or data connection then your mobile phone will not connect to the internet.

The Wi-Fi or this data connection is nothing other than specific waves or frequencies that are transmitted through air.

Vibrations exist in space throughout the entire universe at specific frequencies. For our mobile phones, TVs, Radios and other wireless equipment to work the only thing we must know is how to catch the correct frequencies.

Just as when we want to watch a live telecast, we pay the TV provider to connect our satellite to catch the channel and we are able to enjoy the live programme or when we wish to hear a particular radio station, we turn the dial to catch the specific frequency of that radio station and only then can we enjoy the music.

The exact same process occurs in Yantra. The energy and vibrations are already present and exist in space, the Yantra is simply just a machine that helps us catch them.

Additionally, chanting the Mantra whilst making the Yantra makes this 'machine' much more powerful.

There are three basic sounds of the whole universe "A" "U "M" these sounds vibrate and resonate in various different ways.

All sounds are simply vibrations and all mantras are sacred sounds.

It is the vibrations of mantras which can connect us to higher centres.

For every existence in this world, there is an associated sound. There is a relation between sounds and forms.

German physicist and musician Ernst Chladni demonstrated in the late 18th century how sound vibrations could be used to create specific patterns, forms and shapes in sand on a plate when subjected to different frequencies of sound; as the frequency was altered so was the form and pattern the sand would take. In the 1960's Swiss physician Hans Jenny developed the experiment into the study of vibrational phenomena known as cymatics.

Similarly, for every Yantra, there is an associated mantra or combinations of words with a specific sound or vibration. Together they complete each other.

"MANTRAS ARE THE SOUL AND
YANTRAS ARE THE BODY."

Yantra Making Guide

Before you begin to make your Yantra, here is a quick reminder of what the benefits of Yantra making are:

- Yantra making procedure helps us go beyond the normal framework of the mind.
- Yantra making withdraws our consciousness from the outer world and takes us into the inner world.
- Yantra teaches our mind to concentrate and become one pointed.
- Yantra making connects us to the energies of the cosmos.
- Yantra balances our hemispheres and enhances our decision-making abilities.

Equipment required for Yantra making:

Paper - A3 hot pressed sheets minimum 300 GSM.

Compass – a good quality stable one

Ruler (30cm or longer with millimetres as well as centimetres)

Pencil - 2H

Eraser

Gouache Colours

Brushes - Round tip (no. 1 & no. 3) & Flat brush (no. 1 and no. 3)

Yantra drawing requires and develops:

ACCURACY

ALERTNESS

CONCENTRATION

DISCIPLINE

NEATNESS

PATIENCE

Yantra Making discipline

You need to get into the right frame of mind and be prepared to invest yourself to reap the great benefits. Do not rush the Yantra making as even the steps that seem repetitive or a drag have significance.

Yantras can be made by anyone and at any time of the day. However, it is better that when you sit down for Yantra making you do so in natural light or good light and free yourself from other distractions and duties.

When you start to make a Yantra, do not start another Yantra until you have finished making the current one. This is because Yantra invokes energy and you should not leave it incomplete otherwise it disturbs the energy around you.

Once completed, you can keep the Yantra in your place of meditation or worship.

Please note that for ease of the readers, I have applied cardinal directions throughout the Yantra making steps instead of the directions that apply

to a Yantra. This means that where I refer to North or South, I am pointing towards the top and bottom of the Yantra. The directions of a Yantra do not follow cardinal map and if you wish to learn more about this you can refer to the book of Harish Johari, *Tools for Tantra*.

Bhupur Making Steps

The square based outer structure of the Yantra is called the Bhupur. This is common to all Yantras.

Step 1: Divide your paper into four equal parts to find the centre point of the paper. First make a vertical line dividing the paper in half lengthways and then make a horizontal line dividing the paper in half in width.

Step 2: Place your compass pointer on the centre point (also called the soul dot) and draw a circle of 11.3cm radius.

11.3cm

Step 3: To bisect the circle into 8 equal parts you need to place your compass (set at 11.3cm) pointer on the North most point of the circle and make arcs on either side.

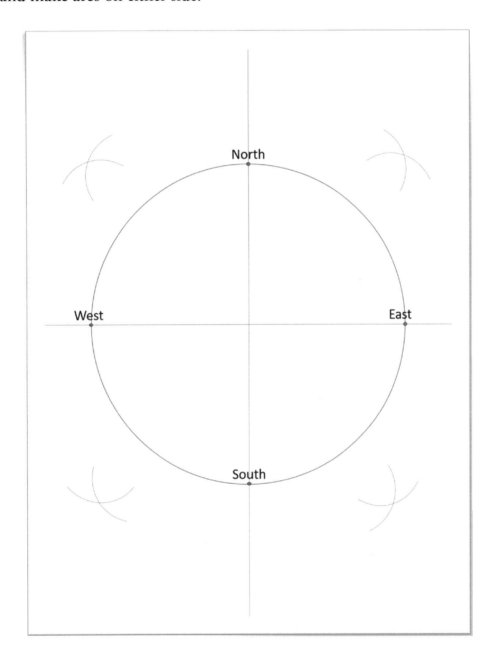

Step 4: Repeat the above step on East, South and West points of the circle. You should end up with 8 arcs. Connect the intersecting points of the arc to bisect the circle with two diagonal lines. These plus the original lines (horizontal and vertical) will now be collectively referred to as the 4 dividing lines.

Step 5: Place your ruler such that it starts at the point where your diagonal dividing line intersects the circle on the left all the way to the point where the diagonal dividing line intersects the circle on the right. Now draw a line of 6cm from the intersecting points on circle as shown below.

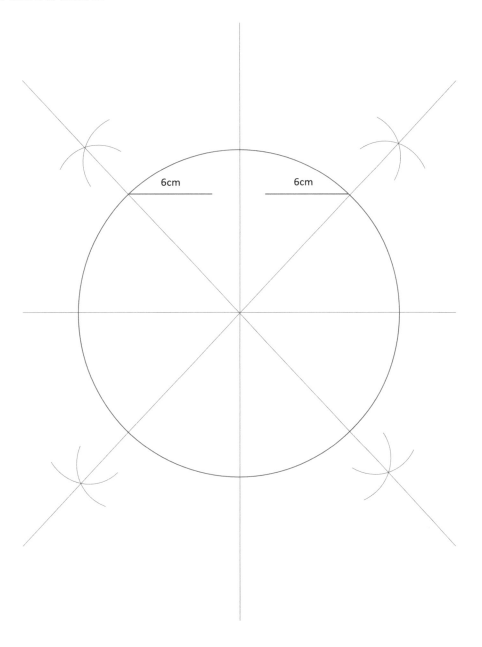

Step 6: You also need to mark two points on the lines you just made. This point is 4cm away from the points where the diagonal dividing lines are intersecting the circle.

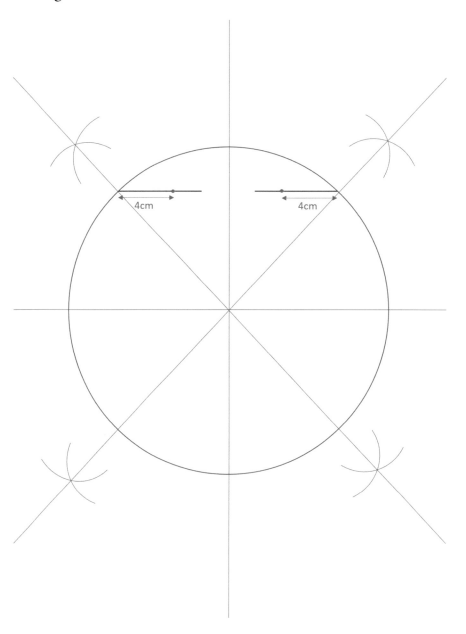

Step 7: Repeat the previous two steps on the other 3 sides to make a square shape with open gaps in the middle.

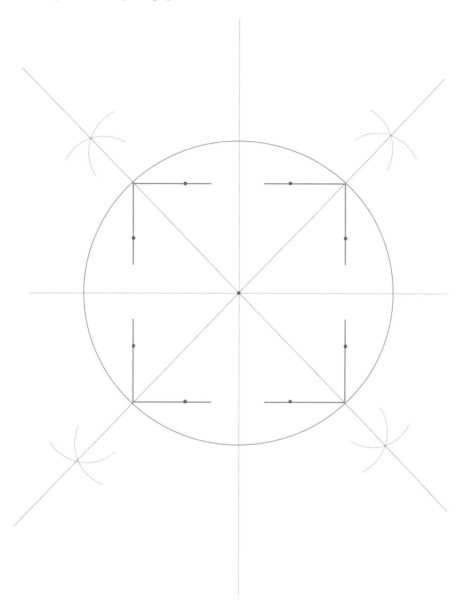

Step 8: You now need to make 2cm long lines from the circle down to the 4cm points you made. Tip: Place your ruler such that it touches the 4cm points you marked on your lines on both of the adjacent lines to ensure that your ruler is straight.

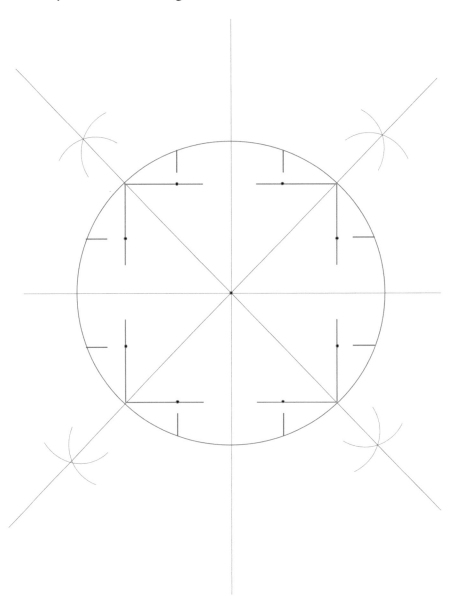

Step 9: Close the top of all the four the gates with a straight line.

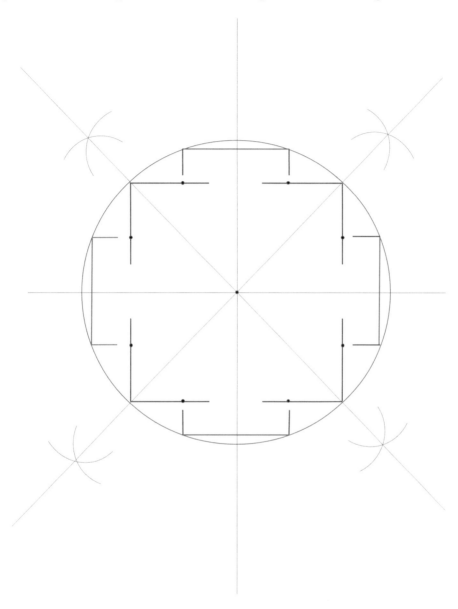

Step 10: Make 2cm long lines inwards - parallel to the previously drawn Bhupur square.

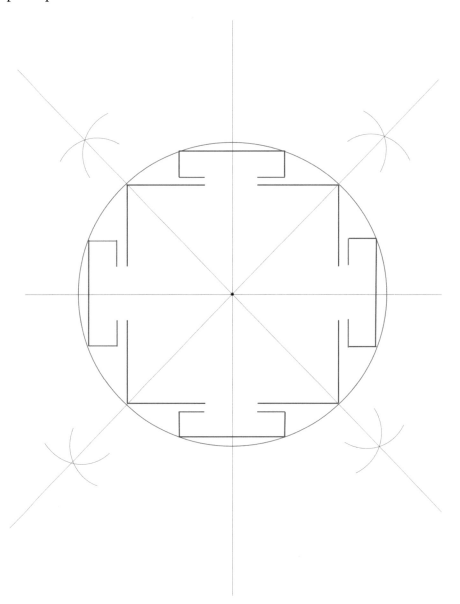

Step 11: Connect the gates to the Bhupur square by making small lines.

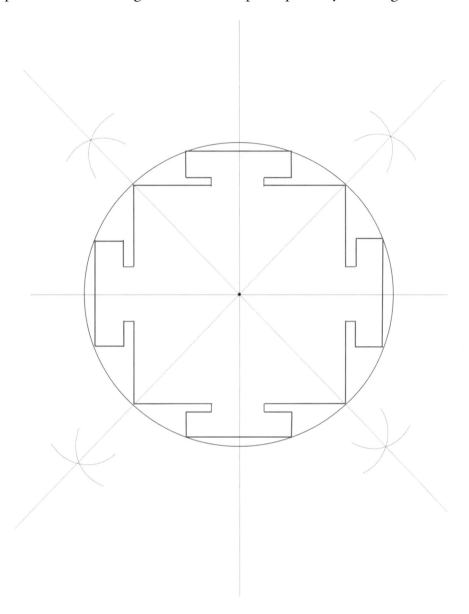

Step 12: Now that you have your single line Bhupur ready you need to make 2 more lines parallel to all the lines, this will be to create borders within the Bhupur. The easiest way to do this is to make your points first and to then connect the lines. Mark with dots points that are 2mm and 4mm on the inside of the Bhupur.

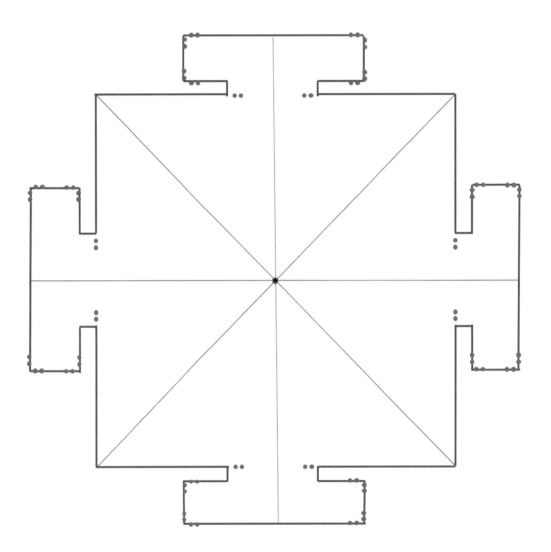

Step 13: Now start to connect the dots like shown in the image below to draw parallel lines to existing Bhupur.

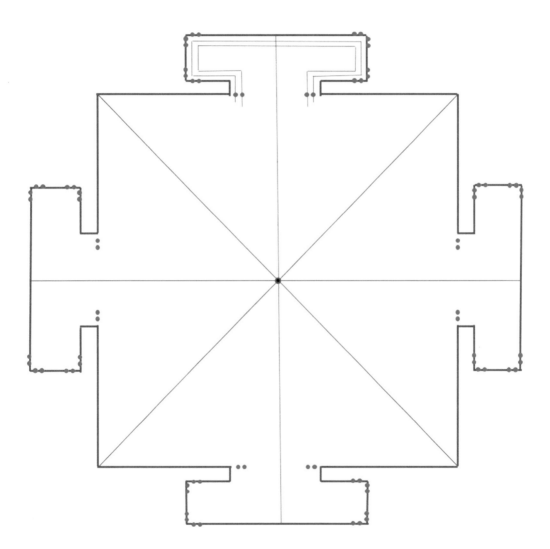

Step 14: Once you have drawn all your parallel lines. Your Bhupur is complete.

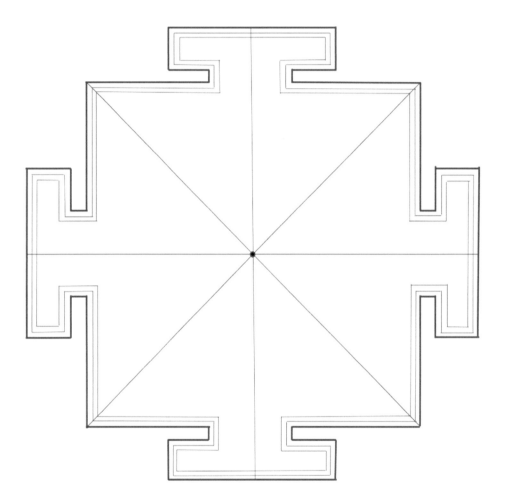

The Ganesh Yantra

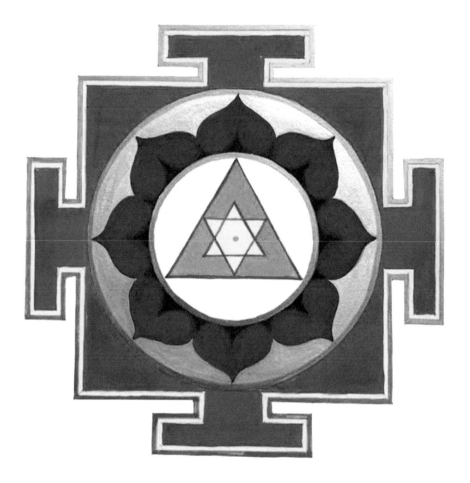

"The first law of thermodynamics, also known as Law of
Conservation of Energy, states that energy can neither
be created nor destroyed; energy can only be transferred
or changed from one form to another."

Hindu religion believes that there are 33 million gods and goddesses. What this number truly signifies is the types of energies that exist. Yantra can connect us with the energy we wish to invoke.

In Hindu dharma whenever anything new is started, it begins with the auspicious name of Ganesha. Hence, the first Yantra we make should be the Ganesh Yantra.

"OM GUM GANPATYE NAMAHA"

Making Ganesh Yantra whilst chanting Ganesh mantra invokes Ganesh's energy.

This energy controls the "rational mind" (left hemisphere of the upper brain) which is the greatest obstacle in the path of spiritual evolution.

It also helps to dissolve the ego and activates both hemispheres of the upper brain and to create a state of deep focus so we can easily meditate.

The physical appearance of Lord Ganesha is also of great significance:

Elephant head represents the power of unlimited energy, broad thinking and wisdom.

Trunk represents alertness and capability to remove all obstacles and destroys negative energies.

Big ears represent listening to everything with full alertness.

Small eyes represent focused vision with one pointedness.

Big belly represents absorbing everything and adjusting.

Broken Tusk represents sacrifice.

Ganesha is the energy that blesses us with wellbeing and the removal of all obstacles from our life.

According to Hindu beliefs, Lord Ganesha had two wives and their names were Riddhi (enlightenment) & Siddhi (attainment). He also had two sons, Ksema (safety, prosperity) and Labha (profit).

The names of the wives and sons here represent the other powers that we seek to get by worshipping Lord Ganesha.

Attributes of the Ganesh Yantra

Yantra is mapping of our body. Through the process of making the Yantra we go within ourself and connect with our soul.

This is why we make the Yantra from the outside in rather than starting from the middle and working out way out.

Each shape within a Yantra is of significance and the colours used are specific as they correspond to a special healing power associated with each colour.

The first thing to note in the Yantra is the outer most square based shape of Yantra.

This is called the Bhupur and it is a representation of our body.

Bhupur has a square based shape which represents stability.

There are four gates in the middle of each side of the Bhupur square. These gates represent our physical body elements - Earth, Water, Air, Fire and Space.

The T-shaped gates are reflective of the importance of balancing of elements in our life.

The 4 gates represent the four main elements (Earth, Air, Fire and Water) and the essence of these four elements is in the fifth element (Space).

If we balance our four main elements then the space element will be balanced by default.

The colours of the Yantra are also of great significance.

The first outline of Bhupur is gold, which is the colour of sun. Gold is known to give clarity and knowledge of spirituality. It heals our mind, body and soul and rids it from any impurities.

The second outline of Bhupur is light yellow colour which provides motivation, hope, positivity and energy to move on the sattvic (pure) path of life.

All the gates and the outer Bhupur structure are filled with green colour. Green colour is known to provide harmony and positive growth. It treats our complexes and provides a sense of wellbeing. This colour is a universal healer.

Next in is the gold circle which represents the expansion of our consciousness. A circle has neither a start nor an end.

This never-ending circle represents the never-ending cycle of time. The moment that we are living now will become our past the next moment and the moment that was our future will become our present. It is very important to understand and accept that cycle and to make the most of our present.

Next is the silver/grey colour around lotus leaves.

Silver represents neutrality and balance. Grey colour is a mix of both white and black and symbolizes the balanced view (middle path).

After the grey/silver are the lotus petals. Lotus petals are a very common feature of Yantras and appear on most Yantras.

The lotus is of great significance and it is seen as a symbol of purity. It is the flower that's often seen in images of the deities and is considered an auspicious flower even though it actually grows in dirty/muddy water.

The lotus conveys to us that if we wish to blossom then we have to rise above the worldly mud. This mud symbolises the world we live in and some of its adversities. This could be politics, greed, jealousy and other negative virtues. The lotus teaches us that we should not be restricted by our circumstances.

The lotus petals are red in colour. This is the colour of the root chakra and hence makes us grounded in our current realities. The colour red is an attractive colour, it's the colour that pulls us into the present moment and encourages us to take action.

After the petals there is another gold circle. This circle represents our THREE GUNAS (three common tendencies) – Rajas, Tamas & Sattava.

There is a constant interplay of these three gunas in everyone's consciousness, but the relative predominance of either Rajas, Tamas or Sattva is responsible for an individual's psychological constitution.

RAJAS individuals can be loving, calm and patient, as long as their own interests are served.

Rajas relates to the qualities of King. They like rich food and a luxurious life style. They are able to bear responsibilities and believe in actions.

At the same time, people in whom Rajas qualities dominate tend to be self-centred, egoistic, ambitious, aggressive, proud, and competitive.

They are hard-working people but may be lacking in proper planning and direction so need others to guide them but still wish to maintain position of authority.

Emotionally they tend to be angry and jealous. They suffer from stress and a fear of failure.

TAMAS means darkness or inertia.

Individuals dominated by tamas are lethargic and tend to only wish to spend their energy in eating, sleeping, and reproducing.

They do not like any mentally straining work and can easily get depressed.

These individuals love 'tamasic' food which is generally food that is very rich and releases a lot of heat and this makes them even more lethargic.

They tend to be greedy, selfish, possessive, materialistic, irritable, and do not care much about others.

SATTVA means pure essence. It implies the reality, consciousness, purity and clarity of perception.

People in whom Sattvic qualities predominate are loving, compassionate, religious and pure-minded. They follow truth and righteousness.

Sattvic people tend to have good manners and positive behaviour and they do not easily become upset or angry.

Although they work hard mentally, they do not get mental fatigue, so, they need only four to five hours of sleep at night. They look fresh, alert, aware, and full of lustre and are recognized for their wisdom, happiness and joy.

They are creative and humble and respect humanity. They love and care for people, birds, animals, and trees and are respectful of every form of life and existence.

After the cycle of gunas comes the big upward pointed triangle that is orange in colour. This represents consciousness, the SHIVA.

Orange colour symbolise emotional balance, harmony, passion, creativity, freedom, intuition, and expression of emotions.

A triangle is composed of three lines. The horizontal line represents stability, and inactivity and it makes the base of triangle. The two slanted lines reaching upwards from either ends of the horizontal line represents reaching the spiritual high awareness.

The yellow star within the Shiva triangle represents the balancing between consciousness and creativeness or the intellectual energy. The yellow colour represents happiness and clarity like the sunlight, and peace of mind body and soul.

The **Golden dot** in the centre represents our soul. This is the part or unit of the divine that brings life to a body. What we refer to as God, is in fact what is present in our core – our soul.

People give this divinity many names, some call it God, the divine, the self, the soul, the life energy, consciousness, the ultimate reality, Allah, Brahma, Moksha. It is all the same.

To meditate on Ganesh Yantra place it in the North direction and chant Ganesh mantra 108 times.

Ganesh Mantra

ॐ गं गणपतये नमः

Om Gan Ganapataye Namaha

Ganesh Yantra Steps

Step 1: Once you have your Bhupur ready. You need to rub off all the extra guidelines to ensure you have a neat and clean Bhupur to start with.

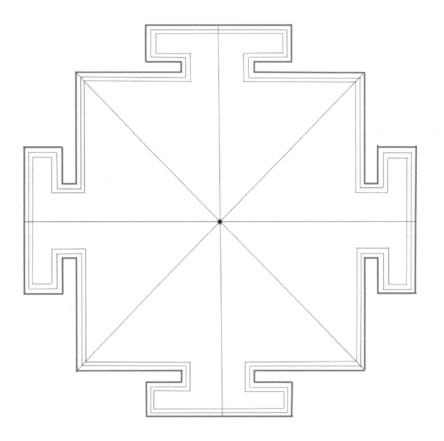

Step 2: From the centre dot (soul dot), make 4 circles of radius 7.5cm, 7.3cm and 5.0cm and 4.8cm using a compass.

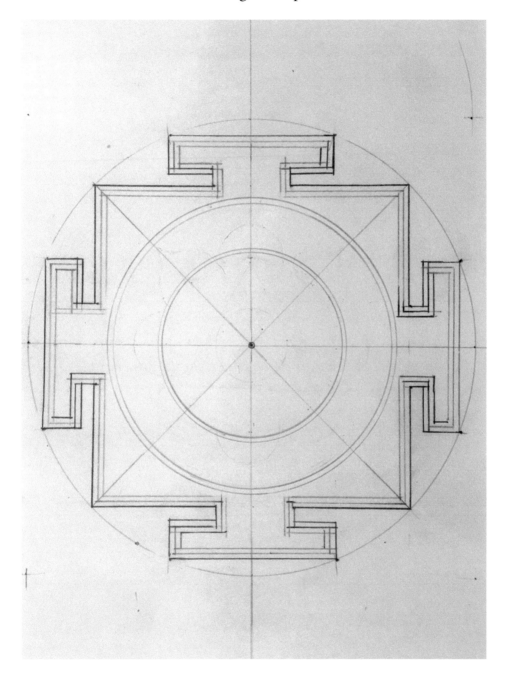

Step 3: Using a compass measure the distance between the points where the dividing lines intersect the inner most circle.

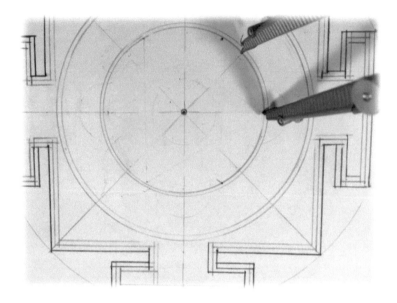

Once you have this measurement, place your compass pointer on each of the 8 points where the dividing lines intersect the inner circle and make arc to bisect the circles further.

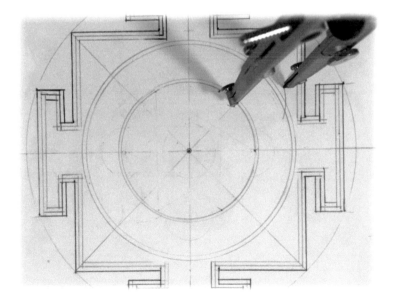

Step 4: Continue to go around the circle to make the intersecting arcs.

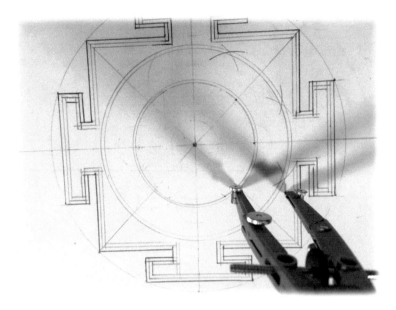

Once you have completed you will have 16 total arcs and 8 points where those arcs intersect.

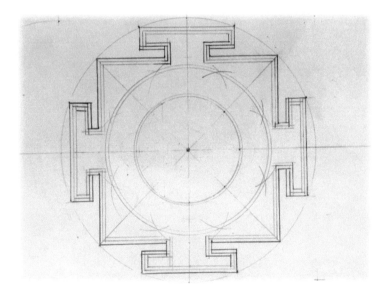

Step 5: Make small lines in the big gap between the circles by placing your ruler such that it connects the adjacent bisect arcs.

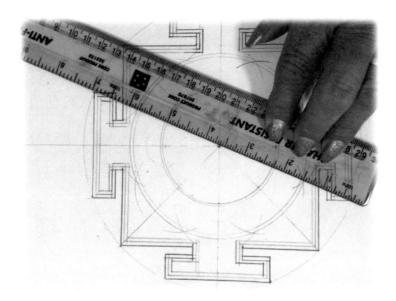

Once completed, your Yantra will appear like shown below:

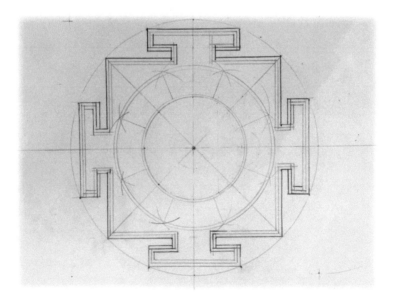

Step 6: Using a compass, draw semi-circles of 2cm radius on each of the points where the dividing lines are intersecting the 5cm circle.

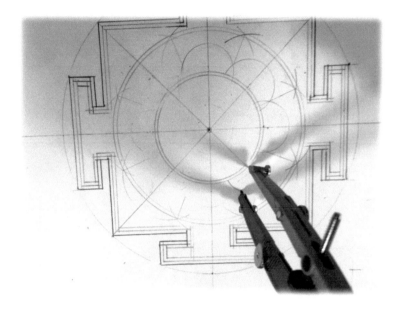

Once completed, you will have 8 semi-circles that overlap slightly.

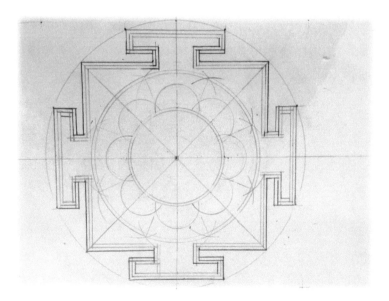

Step 7: Now using the semicircles as a guide, turn it into 8 lotus petals. Tip: Make an inverted 'V' at the centre of each semi-circle – both at the top and bottom (as shown via dotted lines below). Then connect these along the line of the semi-circle.

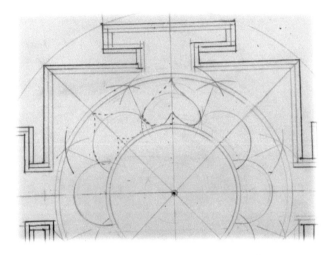

Once, completed you will have 8 petals. Step 8: Using your compass measure the distance between the soul dot and the inner most circle. Now place your compass pointer on the South most point of the inner circle and take your compass to the left and then right and mark small intersecting points on the circle.

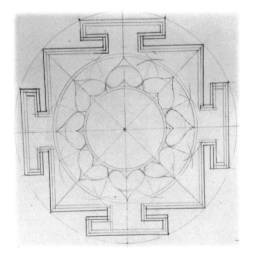

Tip – you can create one perfect petal and then trace it and copy on others.

Step 8: Using your compass measure the distance between the soul dot and the inner most circle. Now place your compass pointer on the South most point of the inner circle and take your compass to the left and then right and mark small intersecting points on the circle.

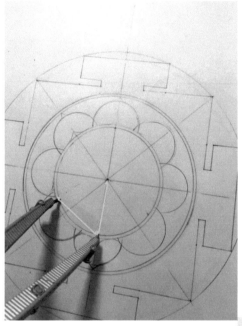

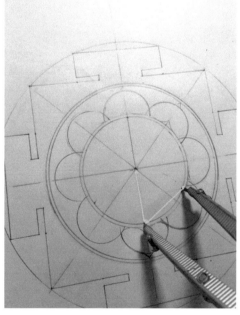

Step 9: Connect the point you just marked on the circle in previous step to the top of the circle (the point where the vertical dividing line intersects the inner circle). You will end up with the triangle.

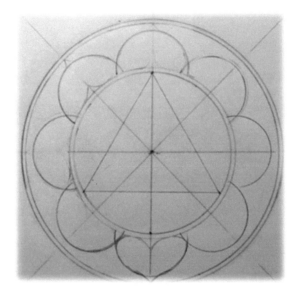

Now double line this triangle leaving a 2mm gap.

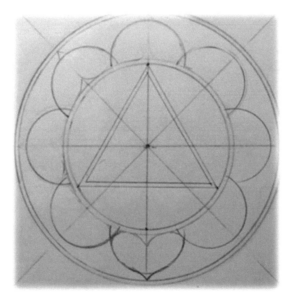

Step 10: Set your compass such that the pointer is at the soul dot and the compass opens up just enough so as to touch the side of the triangle and then make a circle.

Step 11: Put your compass pointer at the South most point of the circle and open it up to the soul dot. Now using this as measurement, make small intersecting marks on the left and the right of the circle. Repeat by placing the compass pointer on North most point of the circle.

Step 12: You should now have 6 points on the circle. The four points you made in previous step plus the South and North point of the circle.

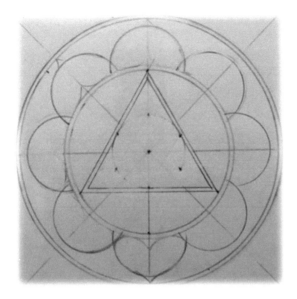

Connect the points by making lines like in the image below and you will end up with a star.

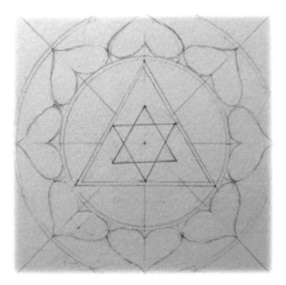

Step 13: Your Ganesh Yantra is now complete. All you need to do is rub off all extra lines and marks before you begin the process of colouring.

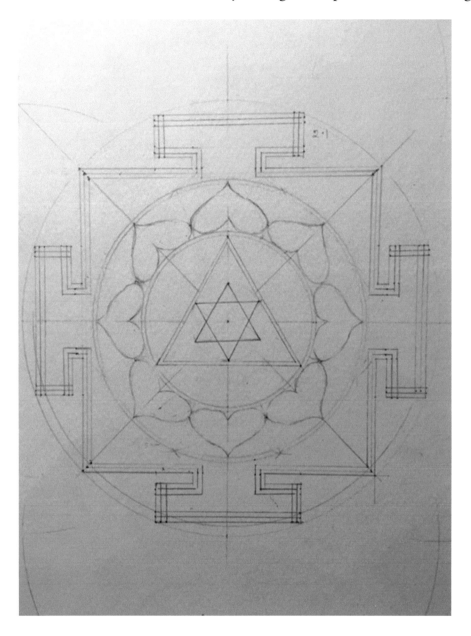

Colouring the Ganesh Yantra

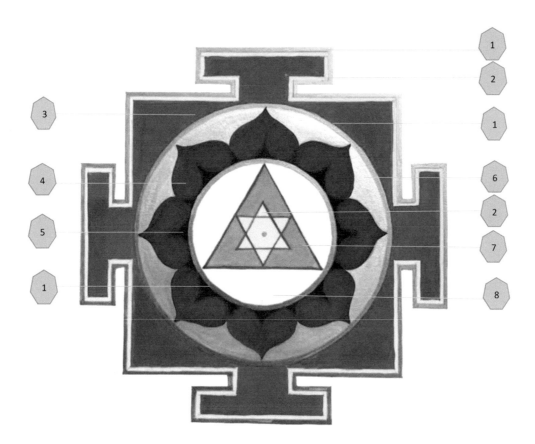

1 Gold
2 Lemon Yellow
3 Spectrum Green
4 Crimson Red
5 Crimson Red with Burnt Sienna
6 Silver
7 Orange
8 White

Lakshmi Yantra

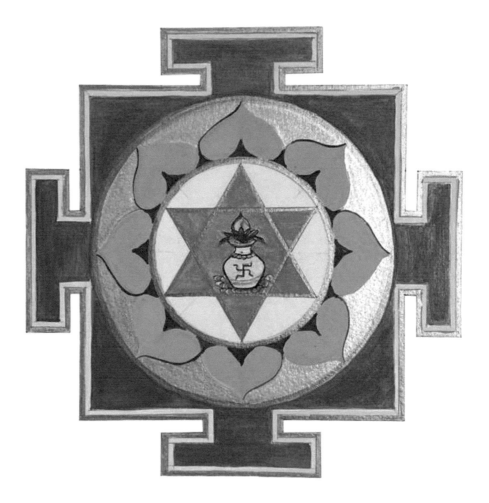

LAKSHMI - THE GODDESS OF WEALTH

Goddess Lakshmi represents one of the three supreme energies. For the creation of the universe the consciousness was divided into three main divine forms – Tri Dev or what are called Brahma, Vishnu and Shiva. Similarly, the energies were divided into three forms – Tri Devi - Lakshmi, Parvati and Saraswati. Goddess Lakshmi represents wealth and prosperity.

Those who seek financial gains or are going through financial problems should make Lakshmi Yantra. Making the Lakshmi Yantra with Vishnu Yantra is even more powerful as Lakshmi is the energy corresponding to Lord Vishnu.

Goddess Lakshmi is associated with the colours red, gold and yellow. These are rich in texture and symbolise wealth and prosperity.

To meditate on Lakshmi Yantra, place it at the North East corner of the house. In front of the Yantra, place a small deepak (ghee lit lamp) and then chant the Lakshmi mantra 108 times. Friday is a good day to meditate on the Lakshmi Yantra.

Lakshmi Mantra

ओम् श्रीं ह्रीम श्रीम कमले कमलालये प्रसीद प्रसीद ओम् श्रीम ह्रीम श्रीम महलक्षमयै नमः

Om Shreem Hreem Shreem Kamley Kamlalaye Praseed Praseed Om Shreem Hreem Shreem Maha Lakshmayea Namaha

Lakshmi Yantra Steps

Step 1: Follow steps in chapter 7 to make a Bhupur. Once you have your Bhupur ready, you need to rub off all the extra lines to ensure you have a neat and clean Bhupur to start with.

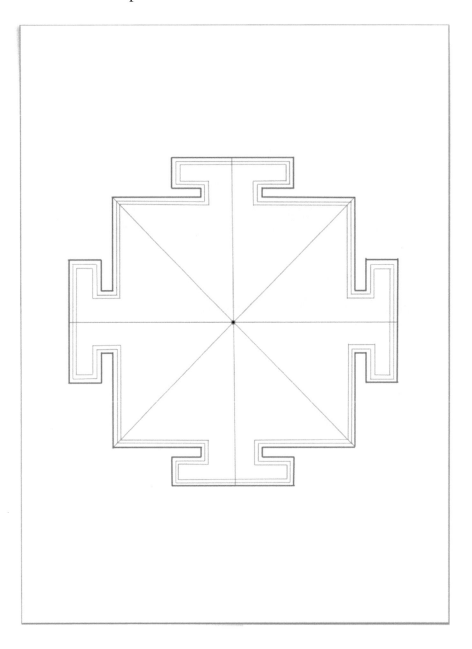

Step 2: Make 4 circles of 7.5cm, 7.3cm, 4.3cm and 4.1cm radius.

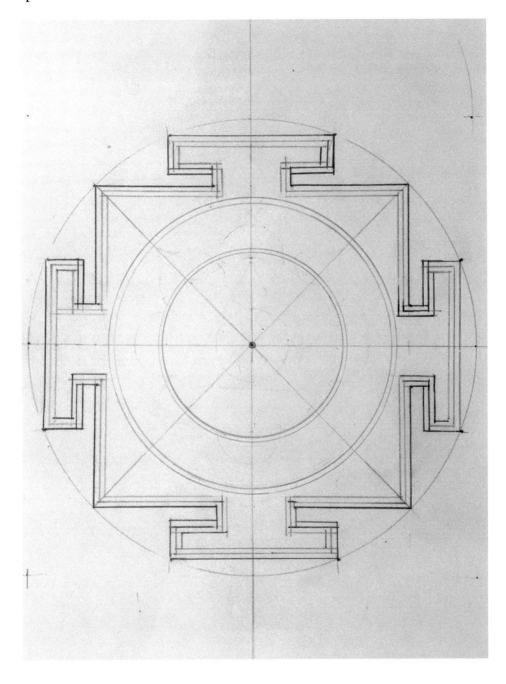

Step 3: Measure the distance between the points where the dividing lines intersect the innermost circle.

Now keeping this width on your compass, make arcs from each of the points where the lines intersect the inner circle to bisect the outer circle.

Step 4: Continue to make arcs from each of the points around the circle.

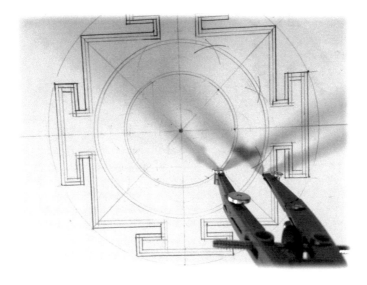

Once finished, you should have 16 arcs that intersect to give you 8 bisecting points.

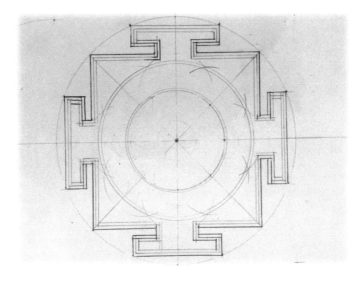

Step 5: Place your ruler such that it connects the adjacent bisecting points and draw lines in between the space between the middle circles.

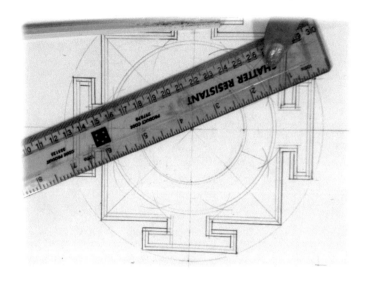

You should make a total of 8 small lines like shown below:

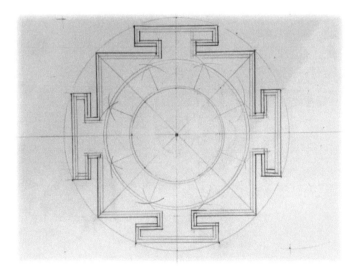

Step 6: Place your compass pointer on each of the points where the lines intersect the second circle from inside and make semi-circles of radius 2cm.

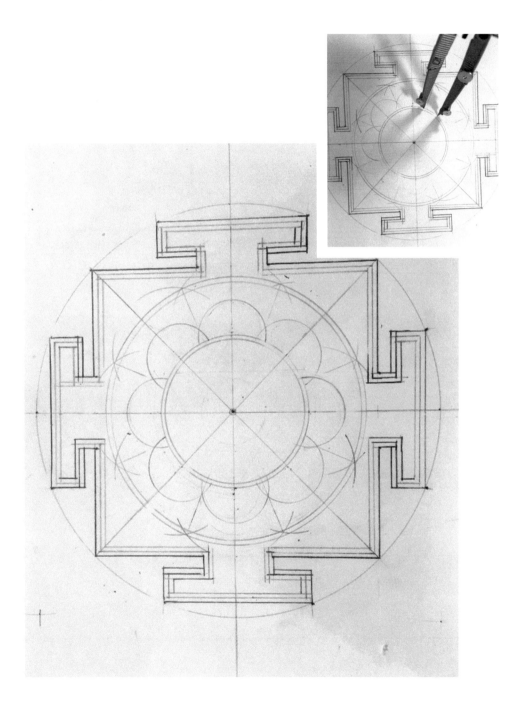

Step 7: Using the semi circles as a guide, turn them into the shape of lotus petals. You can either create all the petals free hand or make one petal and then use a tracing paper to replicate it.

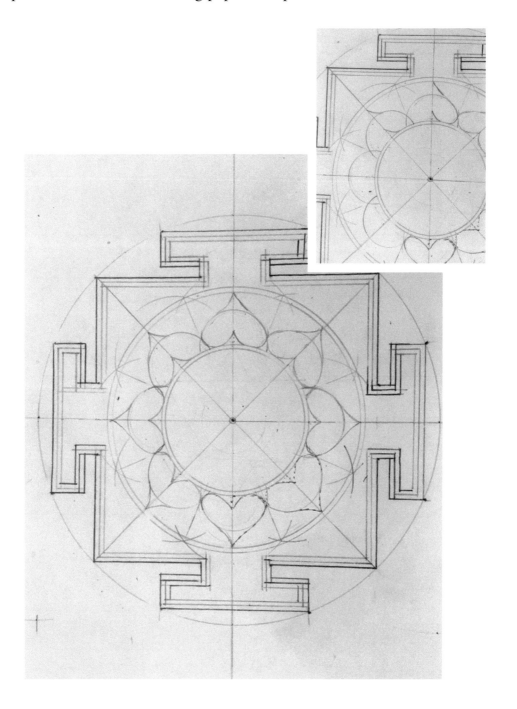

Step 8: Using your compass, measure the distance between the soul dot and the innermost circle. Now place your compass pointer at the South most point of the innermost circle and make small marks on the circle on the right and then left.

Now repeat this by placing the compass pointer on the North most point of the innermost circle and make two more marks. After this you will have 4 marks on the circle that you just made and in addition make a mark on the North and South point on the circle.

Step 9: Connect the North point you just marked on the circle to the lower points you made to create the Shiva triangle.

Now connect the South point of same circle to the higher points you had marked previously. This will make your Shakti triangle and the union of both Shiva and Shakti makes a beautiful star.

Step 10: Lakshmi is the symbol of wealth and prosperity. The final part of the Lakshmi Yantra is a pot of coins that goes within the star. You are encouraged to make this free hand as this enhances the use of the right side of your brain.

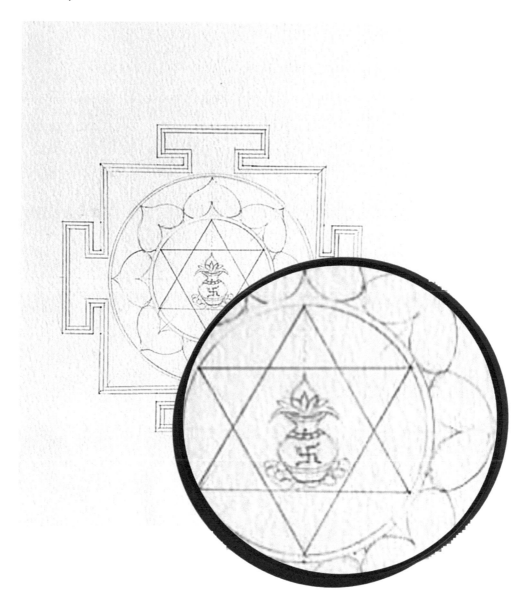

Colouring the Lakshmi Yantra

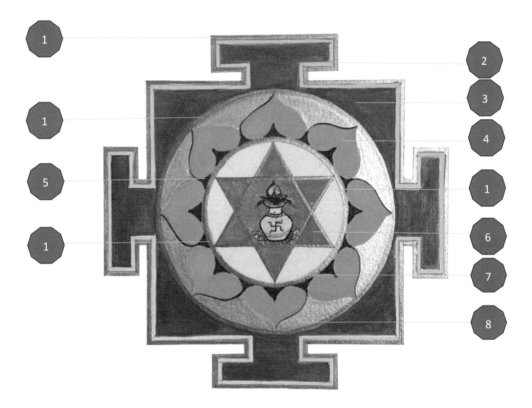

1 Gold
2 Lemon Yellow
3 Viridian Green
4 White with a hint of Rose
5 Rose with a small amount of white
6 Mid yellow
7 White
8 Silver

Parvati Yantra

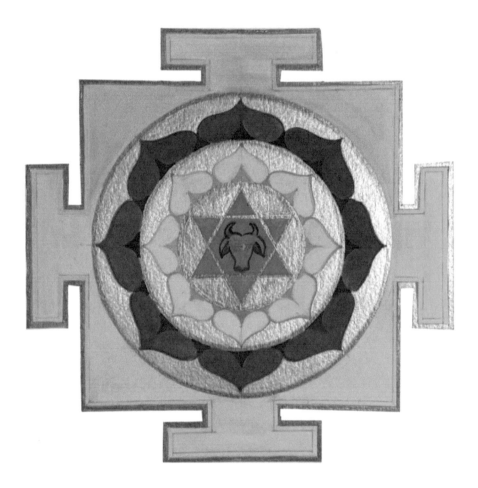

PARVATI - THE GODDESS OF LOVE & STRENGTH

Goddess Parvati is the energy corresponding to Lord Shiva. Whenever righteousness comes in danger, Goddess Parvati takes a different form to destroy the demons and restore peace. Making this Yantra & worshipping Goddess Parvati is said to bring about marriage, resolve conflicts between couples and help prevent miscarriage. Maa Parvati is also worshipped for strength and power.

Maa Durga is a demon fighting form of Goddess Parvati. Durga is worshipped in nine forms called the Navadurga and destroyed evil powers by taking different forms. There are specific and very special Yantras for each of those nine forms of Maa Durga.

Worshipping Parvati Maa gives us power of action and inner strength.

To meditate on the Parvati Yantra, you should place it on the East or North direction of the house. Place a small deepak (ghee lit lamp) in front of the Yantra and offer red flowers and kumkum (sacred red powder) while chanting Parvati mantra 108 times. Monday is a good day for meditation on Parvati Yantra.

Parvati Mantra

ॐ ह्रीं उमायै नमः।

Om Hreem Umayai Namah|

Parvati Yantra Steps

Step 1: Once you have your Bhupur ready. You need to rub off all the extra lines to ensure you have a neat and clean Bhupur to start with.

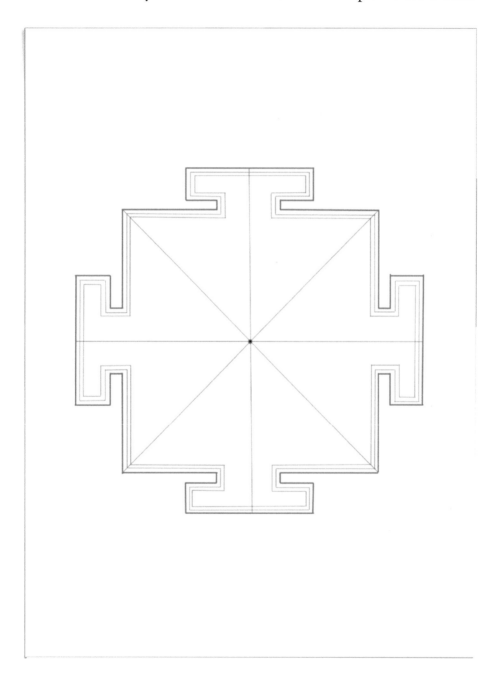

Step 2: Using a compass, make two circles of 7.5cm and 7.3cm radius.

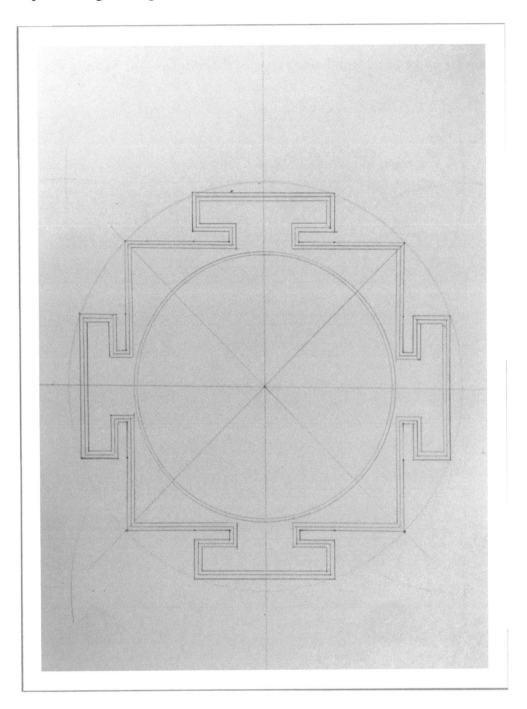

Step 3: Using a compass, make 4 more circles of radius 5.2cm, 5cm, 2.8cm and 2.6cm.

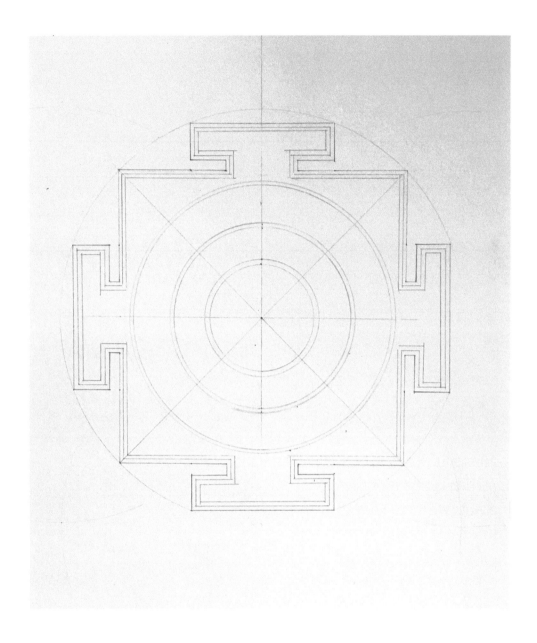

Step 4: To bisect your circle, open up your compass to the width of the distance between the points where the dividing lines cross the 2.8cm circle like shown below.

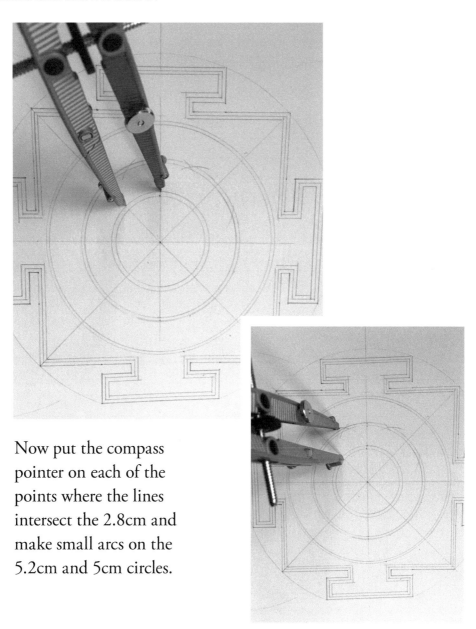

Now put the compass pointer on each of the points where the lines intersect the 2.8cm and make small arcs on the 5.2cm and 5cm circles.

Step 5: Continue all the way around the circle until you have made 16 small arcs that gives you 8 bisecting points where the arcs cross.

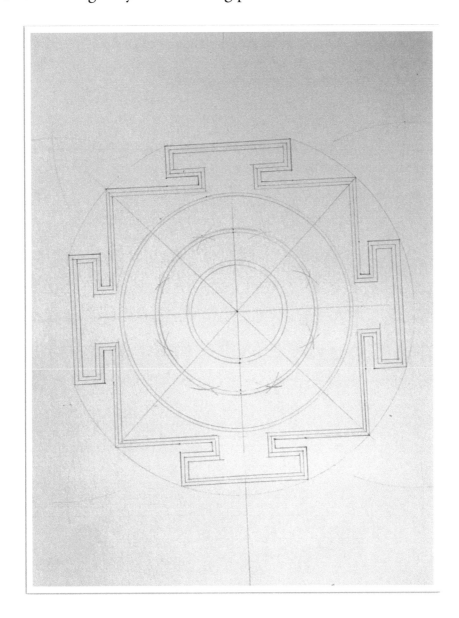

Step 6: Place your ruler such that it touches the soul dot and the adjacent bisect points.

Step 7: Sketch a line that goes from middle circles up to the outer circles. Continue all the way around the circle.

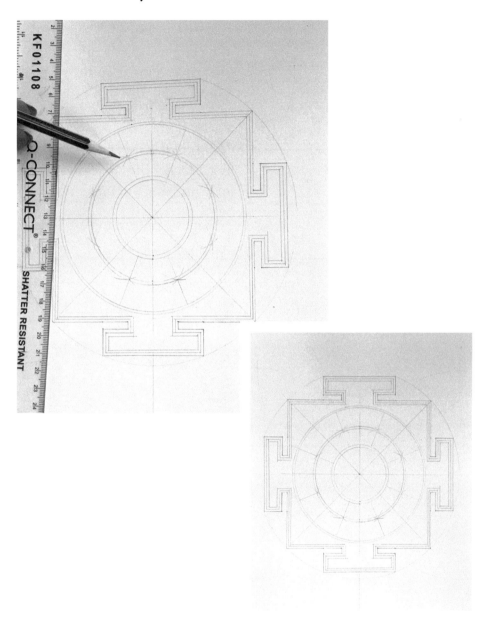

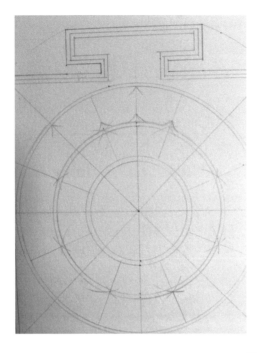

Step 8: The next step is to make the petals. In order to get symmetrical petals, you should first make an inverted V shape at all the points where the lines intersect the circle. Start from the vertical line running through centre of the Yantra and make a

^ (inverted V) shape where the line touches the circle. Every alternate line you will make two

^ shapes – one on top and one below.

Continue to make these all the way around the circle.

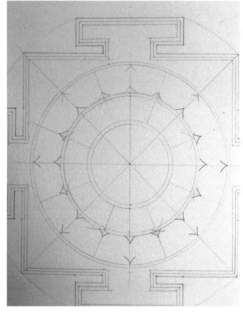

Step 9: The inverted V shapes will help you create the petals that look flawless. Connect the V shape like shown in illustration below.

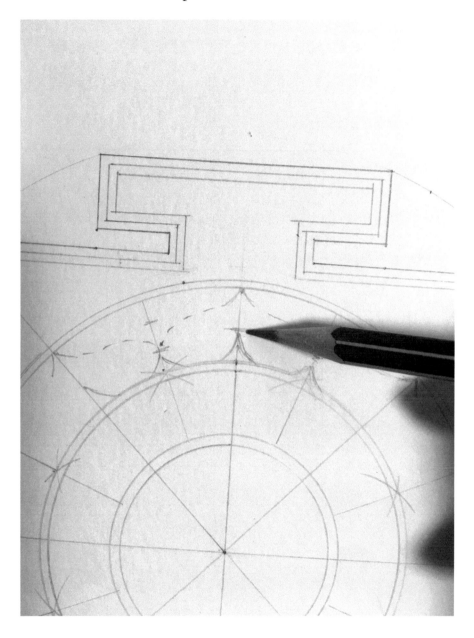

Step 10: Repeat step 8 & 9 in the next layer of circles to create another set of lotus petals.

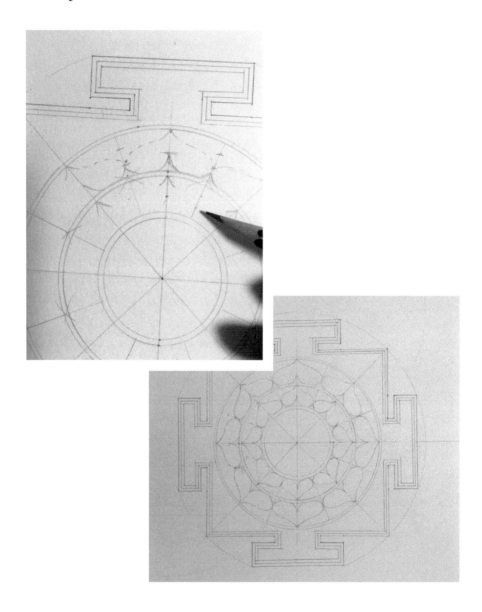

Step 11: Using a compass measure the distance between the soul dot and the innermost circle and then place your compass pointer on the South point of the innermost circle and make a mark (see blue dots) on the circle on the left and right.

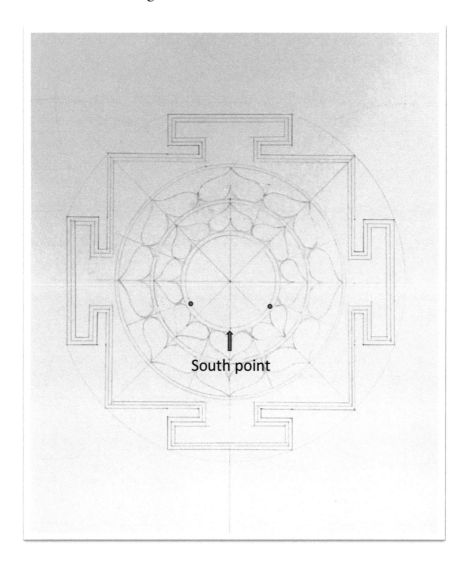

South point

Step 12: Join the two points you marked on the circle to the North point of the innermost circle to create a triangle.

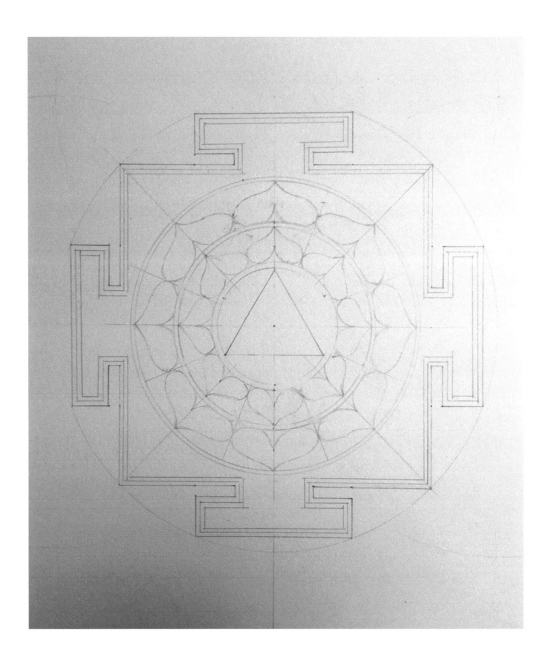

Step 13: Repeat step 11 & 12 from the North point on the innermost circle to create a downward pointed triangle.

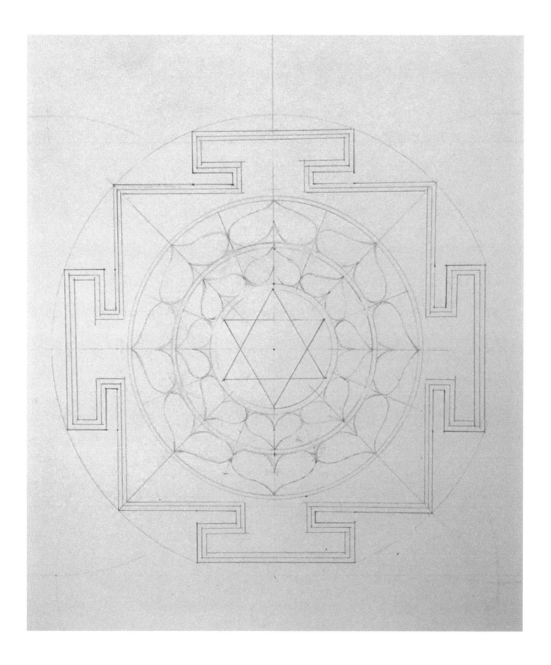

Step 14: Finish off the Parvati Yantra by making the symbol of a bull in the centre of the Yantra.

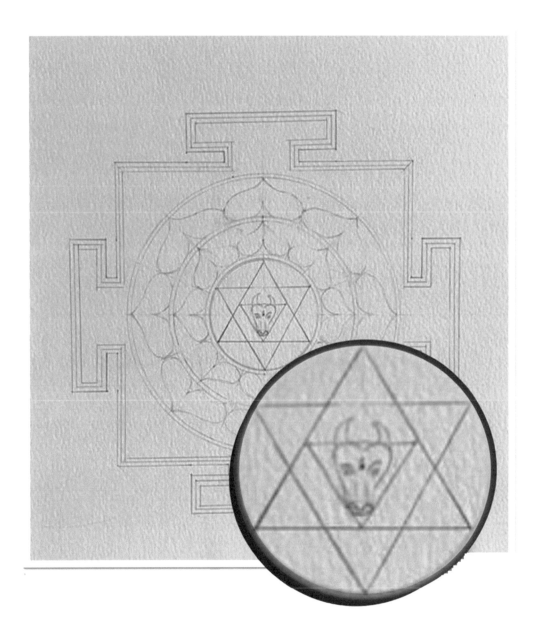

Colouring the Parvati Yantra

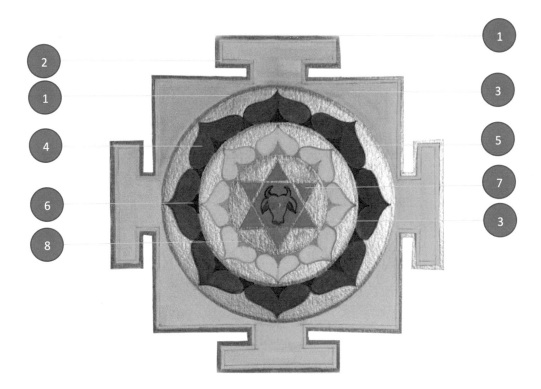

1 Gold
2 Lemon Yellow
3 Mid Yellow
4 Scarlet Red with a hint of Burnt Sienna and White
5 Silver
6 Scarlet Red with Burnt Sienna
7 Ultramarine Blue with White
8 Yellow Ochre

Saraswati Yantra

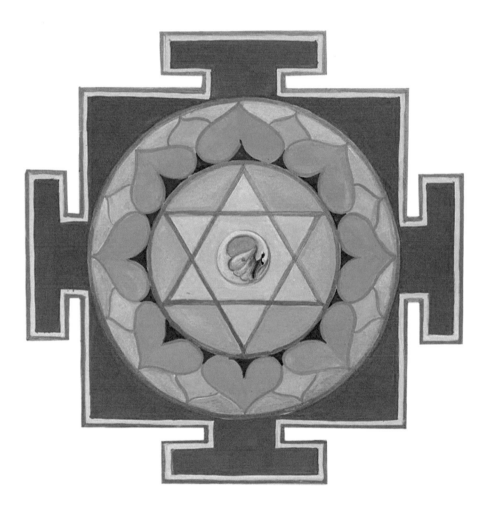

SARASWATI – THE GODDESS OF WISDOM

Goddess Saraswati is the energy corresponding to Lord Brahma, who is the consciousness that created the universe. Creativity requires awareness and Goddess Saraswati is energy that gives the knowledge required for all types of creative forms such as dance, music, arts, writing, inventions and much more. In Indian mythology, a swan is said to eat pearls and be able to separate milk from water.

This is illustrative of a swan's ability to extract wisdom from knowledge. Making the Saraswati Yantra is very beneficial for students of all ages as well as for entrepreneurs and scientists.

Goddess Saraswati is represented by the colour white and this stands for the qualities of peace and purity. She is symbolic of knowledge and art and is the epitome of serenity.

You can keep Saraswati Yantra in your study room or place of work facing the Southwest direction. It is beneficial to make Saraswati Yantra any day however, there is a special pooja on the occasion of Vasant Panchmi (festival that marks arrival of Spring) and it is beneficial to make the Yantra on that day.

To meditate on the Yantra, place it on a yellow cloth and put a small tilak (an ornamental spot) of haldi (turmeric) and kumkum (sacred red powder) on the Yantra. Chant the Saraswati mantra 108 times. It will help you to take right decisions at right time.

Saraswati Mantra

!! ॐ श्रीं ह्रीं सरस्वत्यै नमः !!

Om Shreem Hreem Sarasvatyai Namah

Saraswati Yantra Steps

Step 1: Once you have your Bhupur ready. You need to rub off all the extra lines to ensure you have a neat and clean Bhupur to start with.

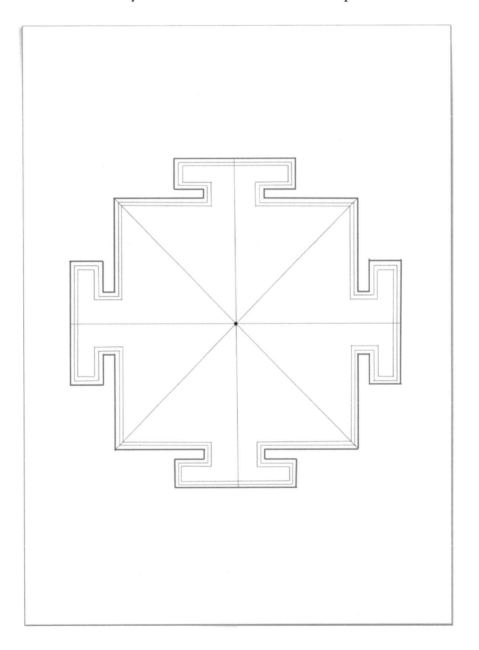

Step 2: Using a compass set at 7.5cm, make a circle from the soul dot.

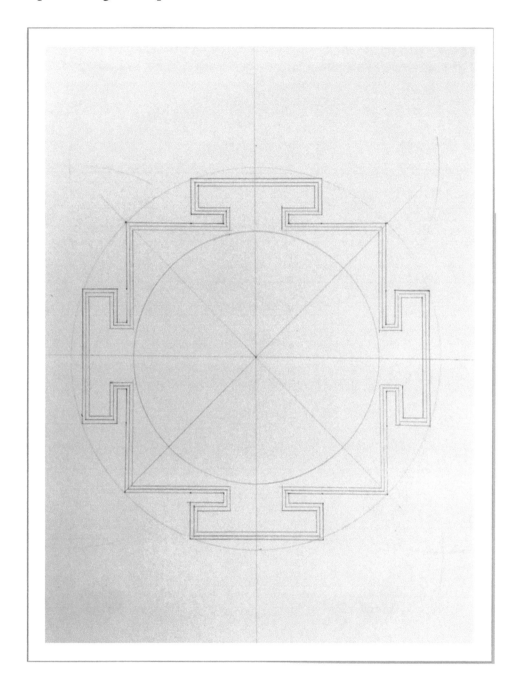

Step 3: Using a compass, make 3 more circles of 7.3cm, 4.3cm & 4.1cm from the soul dot.

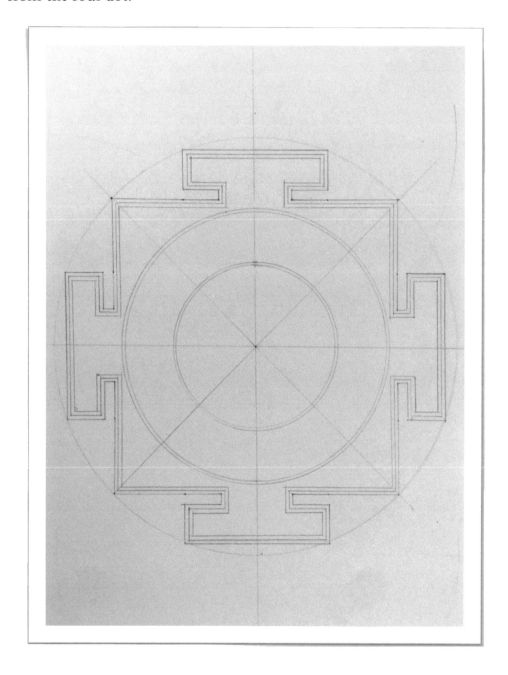

Step 4: Using a compass set at 2cm make semi-circles at all the points where the dividing lines intersect the second circle from inside.

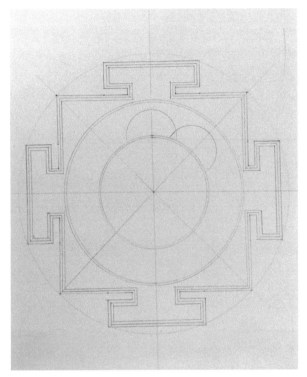

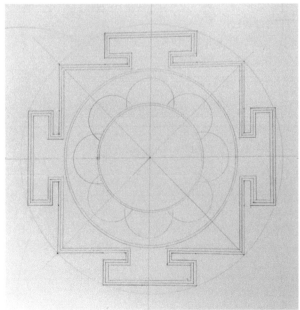

Step 5: Place your ruler such that it connects the soul dot and the point where the semicircles intersect the next semi-circle (as pointed out in picture below).

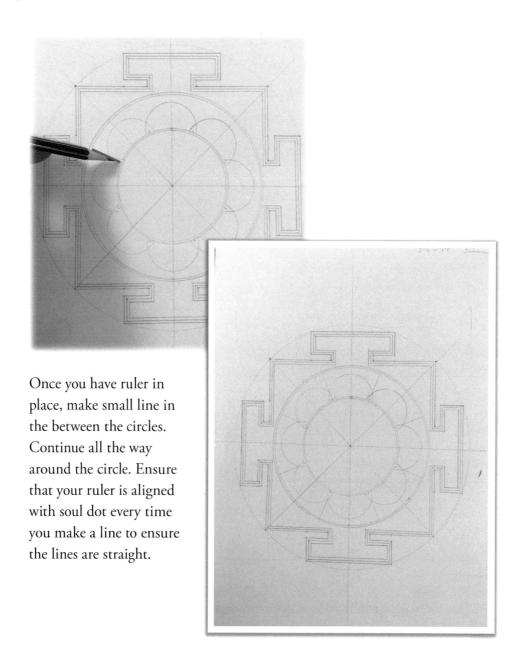

Once you have ruler in place, make small line in the between the circles. Continue all the way around the circle. Ensure that your ruler is aligned with soul dot every time you make a line to ensure the lines are straight.

Step 6: Setting your compass to 2cm, make part semi-circles from the points where the line touches the second circle from the inside.

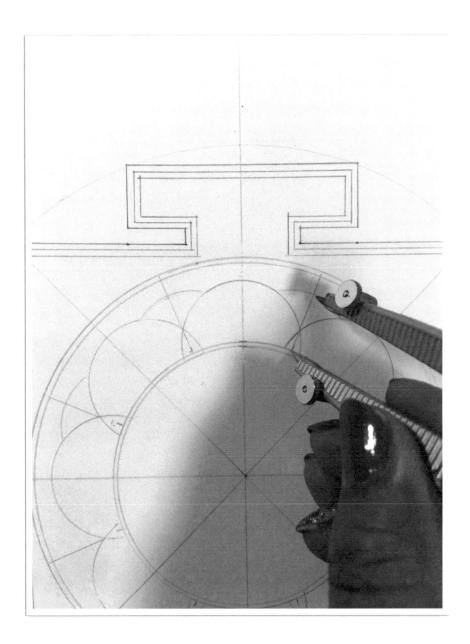

Step 7: Using the semi-circles as a guide, create lotus petals like shown below.

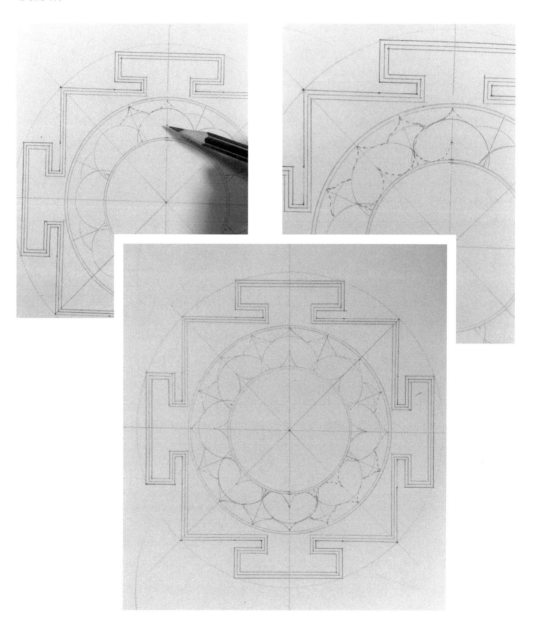

Step 8: Using a compass set the pointer at the South point of the inner-most circle and open it up to the soul dot. Now moving the compass to the right and left mark points where it touches the inner circle.

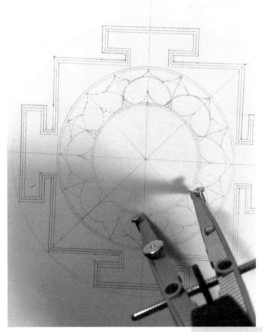

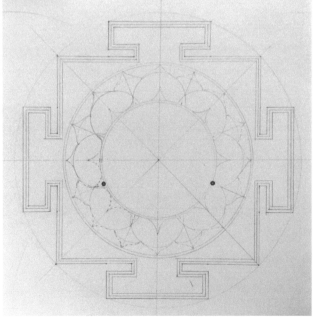

Step 9: Connect the two points you marked on the circle in the previous step to the North most point of the inner circle to create a triangle.

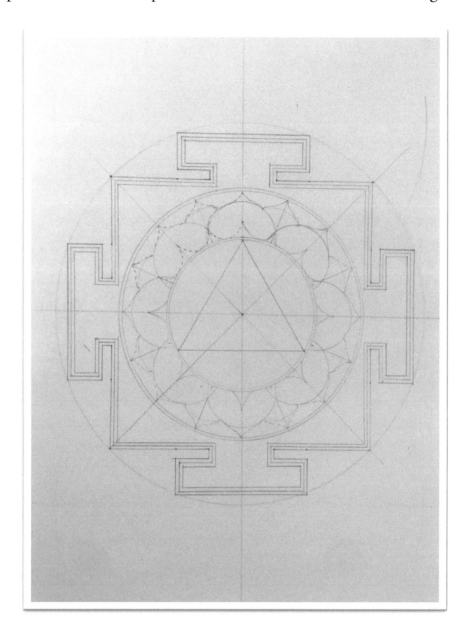

Step 10: Place your compass pointer on the North most point of the inner circle and measure it out up to the soul dot. Now holding this measurement mark the left and right side of the circle.

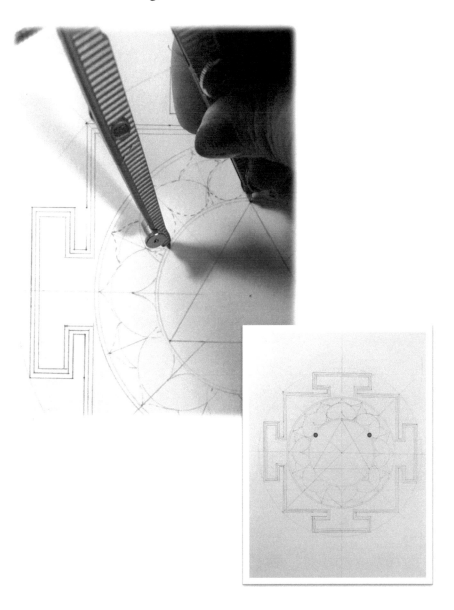

Step 11: Connect the points you marked in the previous step to the South most point of the inner circle to create a downward pointed triangle.

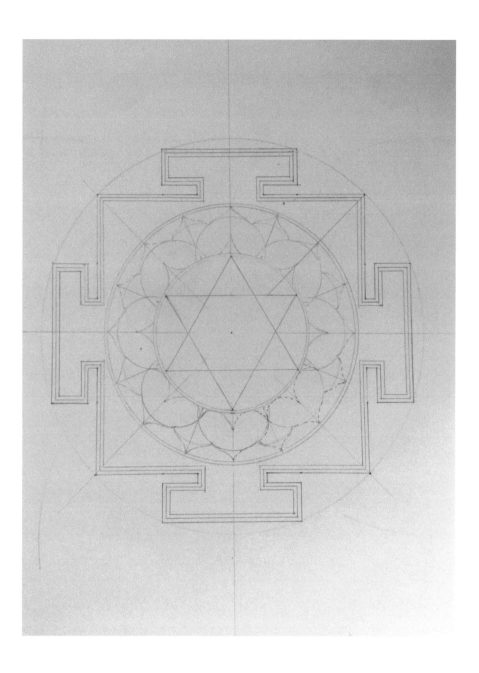

Step 12: Make a 1cm radius circle from the soul dot and use this as a guide to make the shape of a swan – the symbol of Maa Saraswati. Your Saraswati Yantra is now ready to colour.

Colouring the Saraswati Yantra

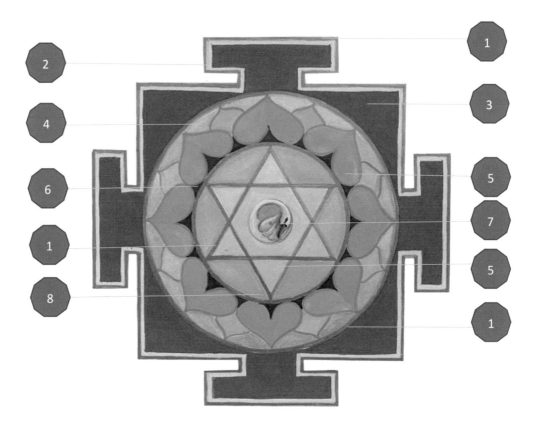

1 Gold
2 Lemon Yellow
3 Sap Green with a hint of Viridian Green
4 Silver
5 Ultramarine blue & white
6 Ultramarine blue
7 Swan – white and blue
8 Pink

Brahma Yantra

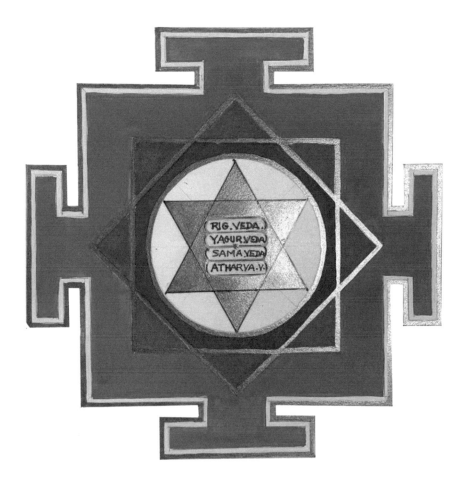

RIG. VEDA.
YAGUR VEDA
SAMA VEDA
ATHARVA. V.

BRAHMA - THE GOD OF CREATION

Lord Brahma is worshipped as the creator of the whole universe (Brahmand). He is the architect of the golden ratio on which every living thing is designed.

Worshipping Lord Brahma truly connects us to our roots and gives us the same joy that we get when connecting with nature around us.

Lord Brahma is worshipped as the creator of the whole universe (Brahmand). He is the architect of the golden ratio on which every living thing is designed.

Worshipping Lord Brahma truly connects us to our roots and gives us the same joy that we get when connecting with nature around us.

Lord Brahma has four heads and each of these represent our original Vedas (scriptures), consisting of the Rig Veda, Sama Veda, Yajur Veda, and Atharva Veda.

Lord Brahma is the first of the Trimurti (The three supreme gods of Hinduism). There is a myth that Lord Brahma was cursed and hence nobody worships him. However, Lord Brahma is the consciousness corresponding to the energy of Devi Saraswati.

Hence, if we create or meditate on Brahma Yantra with Saraswati Yantra it enhances our creativity and gives us knowledge as Devi Sawaswati is the goddess of wisdom.

Place Brahma Yantra facing the South-West direction and offer the food we make for ourselves. Chant the Brahma mantra 108 times. In doing this we can receive the divine vibrations.

Brahma Mantra

ॐ श्री ब्रह्मणे नमः

Om Shree Brahmane Namaha

Brahma Yantra Steps

Step 1: Once you have your Bhupur ready. You need to rub off all the extra lines to ensure you have a neat and clean Bhupur to start with.

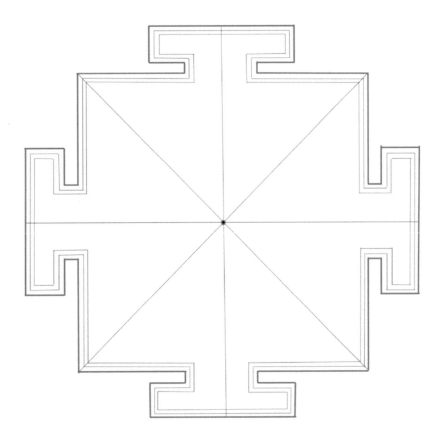

Step 2: Identify and mark the half way point between the gates (where the dividing lines are), Mark these points on all four sides. This should be at 7.6cm from the soul dot.

Step 3: Connect the four points you marked in the previous step to make a square.

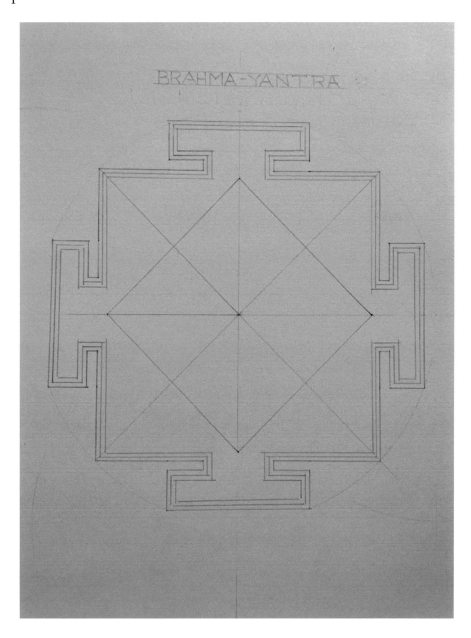

Step 4: Using a ruler, mark the points on the diagonal dividing lines at 7.6cm away from soul dot. This is the same distance as you previously marked for the first square.

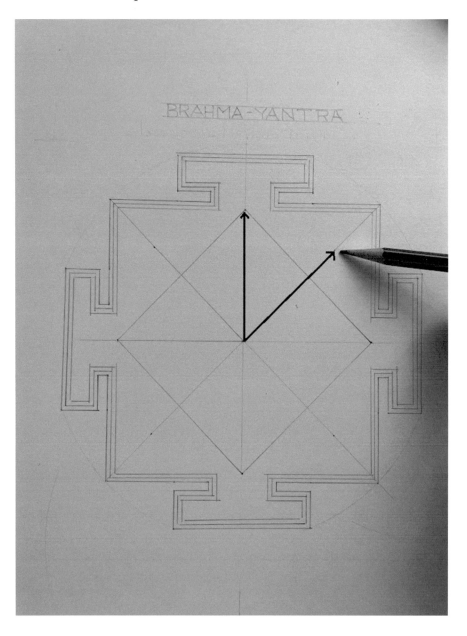

Step 5: Connect the points you just marked in the previous step to make a square.

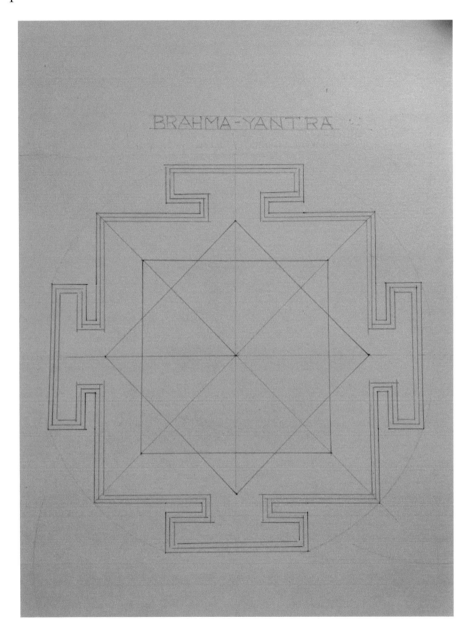

Step 6: Double the lines on the inside of both the squares at 2mm away from the original lines.

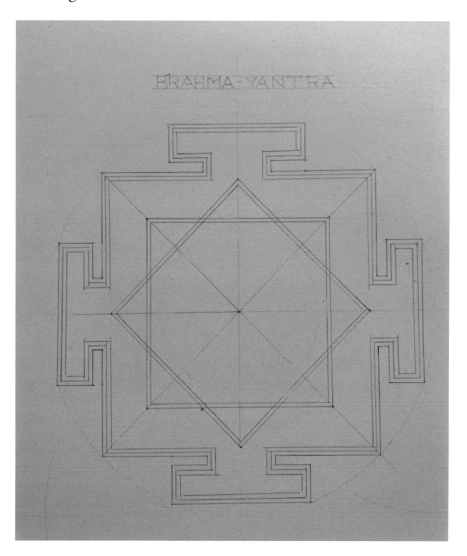

Step 7: Using a compass make two circles of radius 3.8cm and 3.6cm.

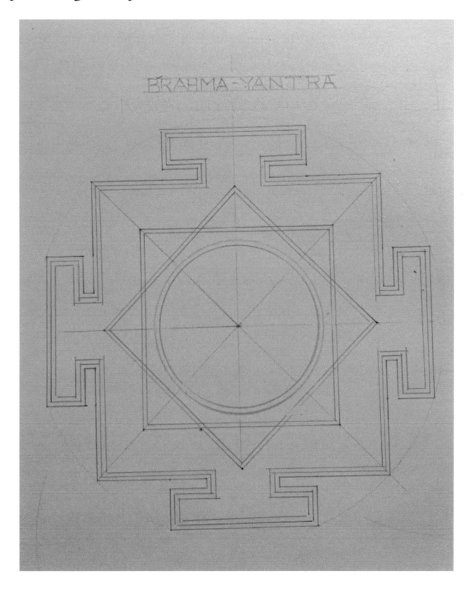

Step 8: Using a compass place the pointer on the South point of the innermost circle and then open up the compass up to the soul dot. Now swing your compass left and right and mark the points on the inner circle on left and right. Join these points in a straight line and also to the North point of the circle to create a triangle.

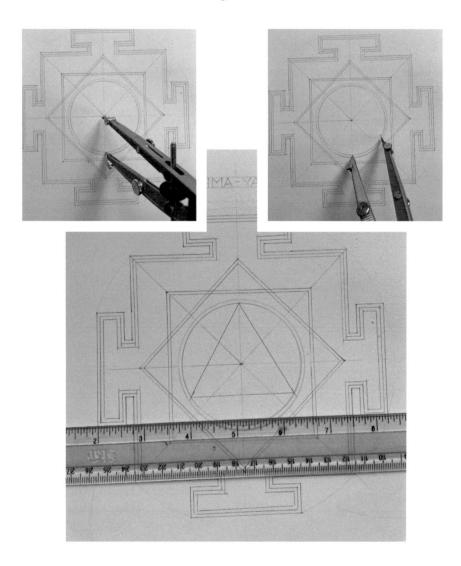

Step 9: Repeat the previous step from the North point of the innermost circle to create a downward pointed triangle.

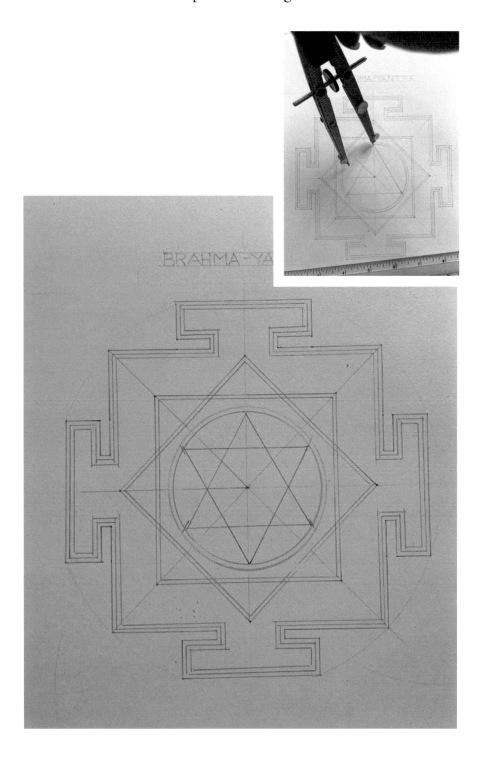

Step 10: Create 4 oval shapes, 2 above the horizontal dividing line and two below.

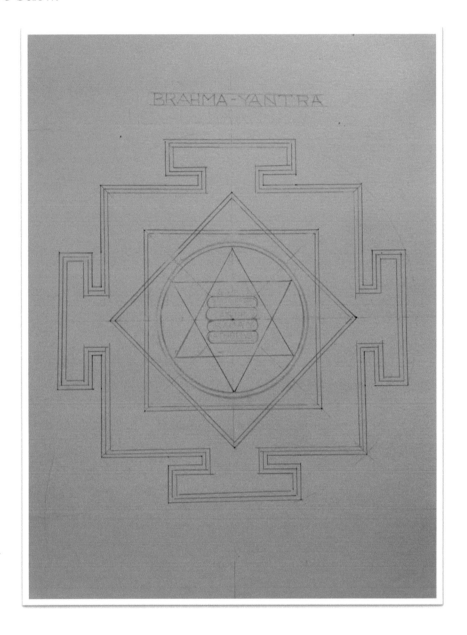

Step 11: Write the names of the 4 vedas in the 4 oval shapes.

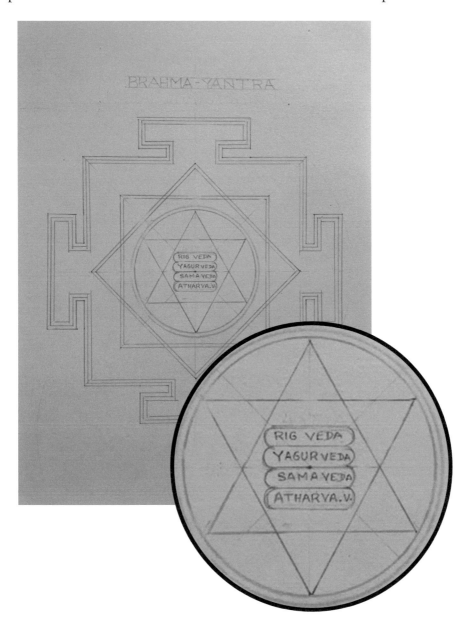

Colouring the Brahma Yantra

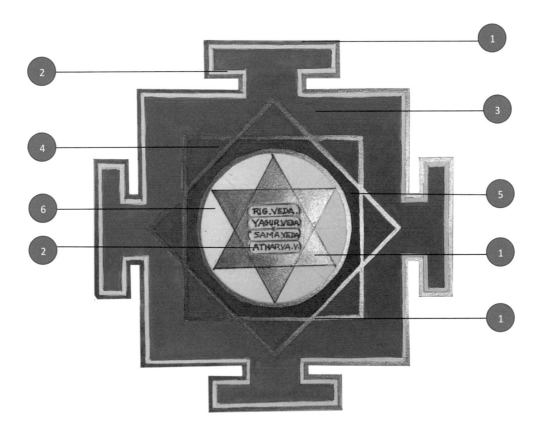

1. Gold
2. Lemon Yellow
3. Cerulean Blue plus Viridian Green
4. Orange
5. Orange with a hint of Vermilion Red
6. White

Vishnu Yantra

VISHNU - THE GOD OF PRESERVATION

Known as the preserver, Lord Vishnu is one of three supreme Hindu deities, along with Brahma and Shiva. Lord Vishnu's role is to protect humans and to restore order to the world. His presence is found in every object and force in creation, and some Hindus recognize him as the divine being from which all things come.

Known as the preserver, Lord Vishnu is one of three supreme Hindu deities, along with Brahma and Shiva. Lord Vishnu's role is to protect humans and to restore order to the world. His presence is found in every object and force in creation, and some Hindus recognize him as the divine being from which all things come.

Worshipping Lord Vishnu gives us the power of inner management and are able to restore any imbalance within us.

According to Hindu mythology, whenever righteousness is in danger, Lord Vishnu takes birth in different avatars to restore peace and balance.

When we feel that our life is imbalanced or when we feel that there is too much negative energy around us and within us then we should make Vishnu Yantra.

To meditate on Vishnu Yantra place it in the North-East direction. Early morning (between 4AM and 6AM) is the best time to meditate on this Yantra. Light a small deepak (ghee lit lamp) and focus on the flame while chanting the Vishnu mantra 108 times.

Vishnu Mantra

मङ्गलम् भगवान विष्णु:, मङ्गलम् गरुणध्वज:।
मङ्गलम् पुण्डरी काक्ष:, मङ्गलाय तनो हरि:॥

Mangalam Bhagwan Vishnuh, Mangalam Garunadhwajah।
Mangalam Pundari Kakshah, Mangalaya Tano Harih॥

Vishnu Yantra Steps

Step 1: Once you have your Bhupur ready. You need to rub off all the extra lines to ensure you have a neat and clean Bhupur to start with.

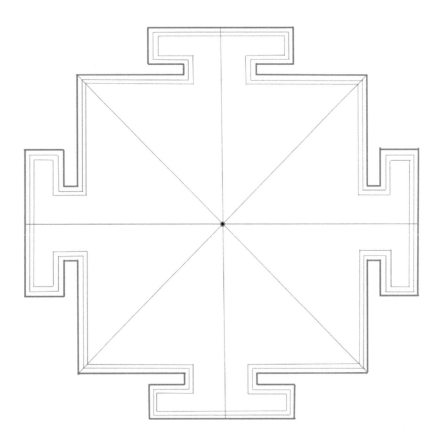

Step 2: Using a compass, make 3 circles from the soul dot with radius 7.7cm, 5.5cm & 5.3cm.

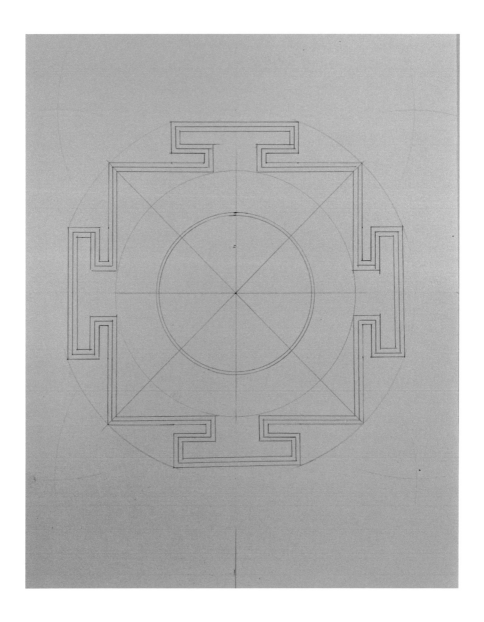

Step 3: Place the compass pointer on East point of the 7.7cm circle and make small arcs cutting the circle on left and right.

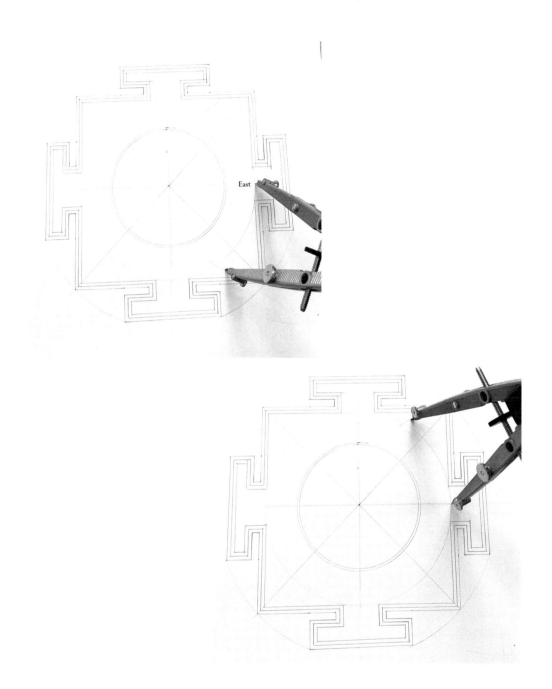

Step 4: Repeat the previous step from the North, West and South point of the circle.

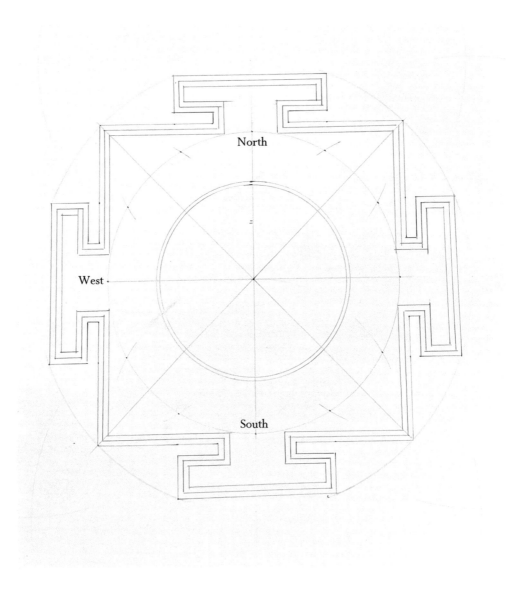

Step 5: Place your ruler such that it is adjacent to the diagonally opposite points you just marked on the circle and draw a small line in the gap between the circle. Repeat this step all around the circle.

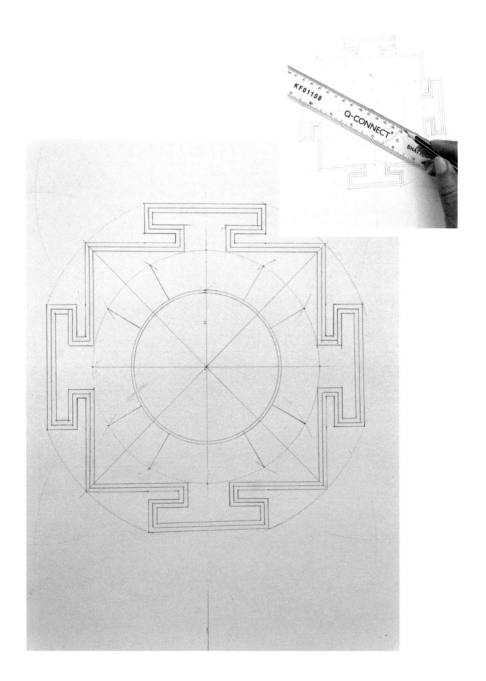

Step 6: Using a compass, draw semi-circles of 2cm radius from the base point of the small lines you have made in the previous step.

Make 12 semi-circles in total.

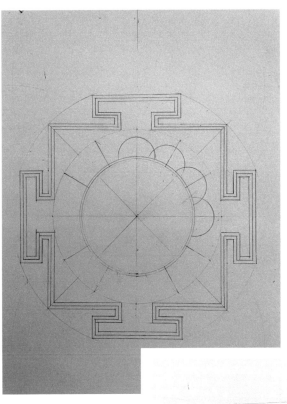

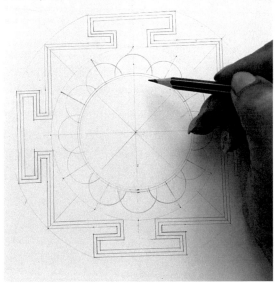

Step 7: Below is a step-by-step guide to making lotus petals.

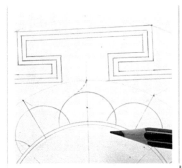

Connect the center point on top of the semi-circle to the side of the semi-circle.

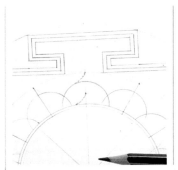

Make a small arc from the halfway point in the semi-circle to the base of semi-circle.

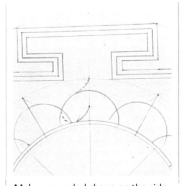

Make a rounded shape on the side of the semi-circle to complete the side of the petal.

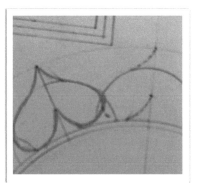

Repeat these steps on all of the semi-circles to complete the petals.

Step 8: After completing the petals in the first layer, similarly make petals in the second layer.

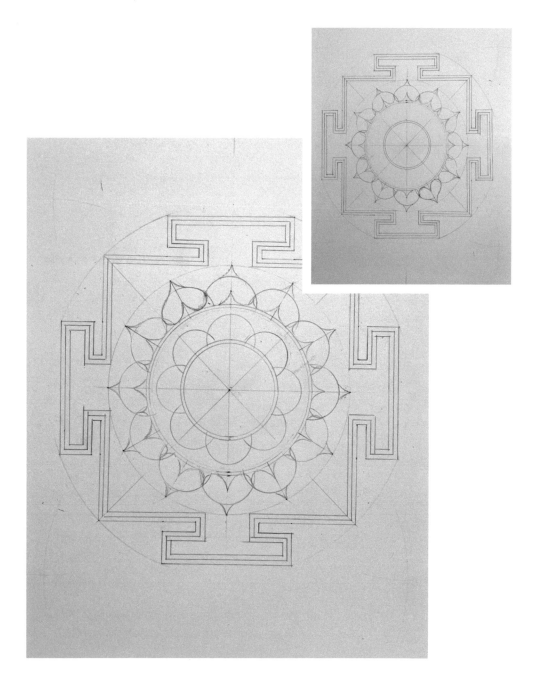

Step 9: Place the compass pointer on the South point of the innermost circle and open it up to the soul dot. Using this as your measurement, swivel the compass left and right and mark points on your innermost circle. Connect these points to get the base of your triangle, now connect the ends of the line you just drew to the North point of the circle to get a triangle. Double this triangle with another line 2mm apart.

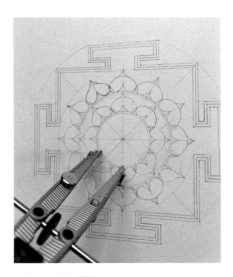

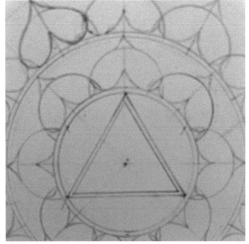

Step 10: Repeat the previous step from the North point of the innermost circle to create the inverted triangle and complete the star.

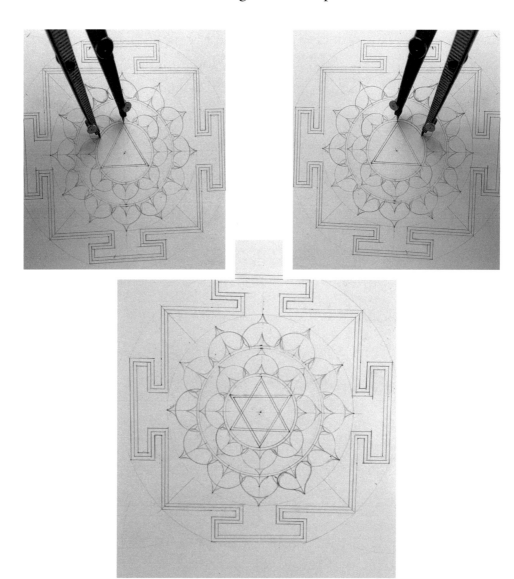

Step 11: Draw 5 symbols of Lord Vishnu. You can draw this free hand and this can enhance your creative side or you may wish to follow the step-by-step illustration in the next page.

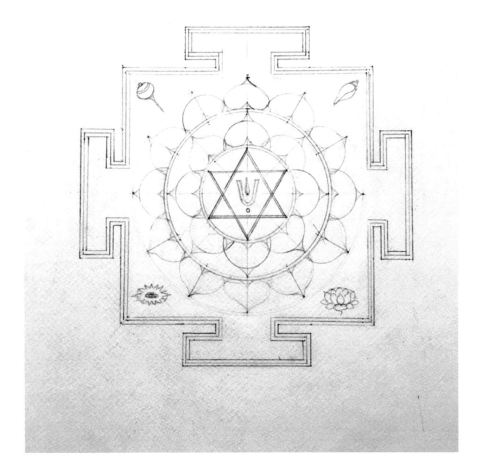

The Mace/Gada

The Conch

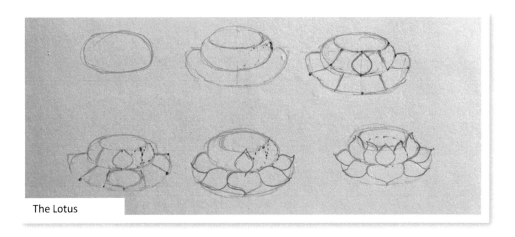

The Lotus

The Discus

Colouring the Vishnu Yantra

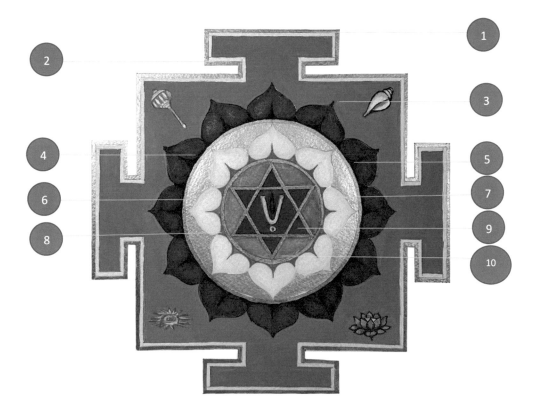

1 Gold
2 Lemon Yellow
3 Ultramarine blue with white and a hint of red
4 Crimson Red
5 Burnt Sienna
6 Silver
7 Lemon Yellow
8 Mid Yellow or Orange
9 Ultramarine Blue
10 Sap Green

1. Mace/gada – Orange, yellow & burnt sienna
2. Shankh/conch – White/black
3. Lotus – Crimson red with white
4. Chakra/Discus – Gold, orange and yellow & burnt sienna

Shiva Yantra

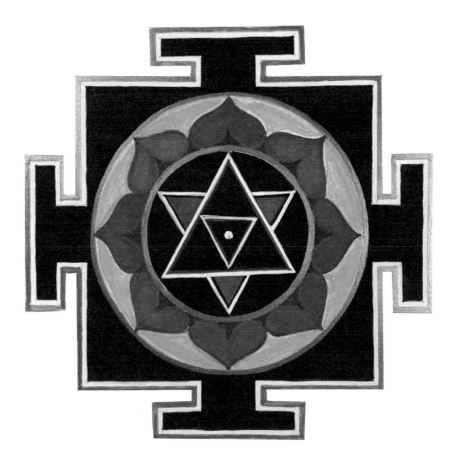

SHIVA - THE GOD OF DESTRUCTION

Lord Shiva is the third of the Trimurti and is known as the god of destruction. Whilst Brahma creates and Vishnu is in charge of the upkeep, Shiva is responsible for the destruction of the universe. The destruction is as important as the creation as only once we let go of the old, do we pave way for the new and evolved.

Lord Shiva is the third of the Trimurti and is known as the god of destruction. Whilst Brahma creates and Vishnu is in charge of the upkeep, Shiva is responsible for the destruction of the universe. The destruction is as important as the creation as only once we let go of the old, do we pave way for the new and evolved.

Shiva is a god who has a lot of different and contradicting aspects – He is both good and bad, both strong yet naïve, and hence why he is referred to as both as Rudra (Fierce) and Bhola (innocent).

Making Shiva Yantra gives us pure consciousness and helps us detach ourselves from the illusionary world around us. It helps us attain moksha (salvation).

To meditate on Shiva Yantra, place it on the East wall (facing the West), near the entrance of home, office, shop, study or living room.

Offer white flowers, kheer (rice pudding) and bel patra. Monday is a good day to meditate on this Yantra and making this Yantra on Shivratri helps give us what we desire.

In India, Unmarried girls usually worship Shiva on 16 consecutive Mondays to get their desired life partner.

Shiva Mantra

ॐ नमः शिवाय

Om namah shivaay

Shiva Yantra Steps

Step 1: Once you have your Bhupur ready. You need to rub off all the extra lines to ensure you have a neat and clean Bhupur to start with.

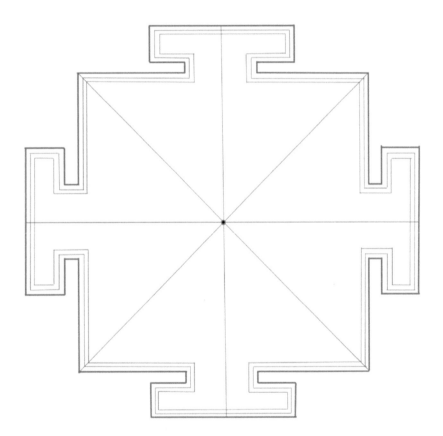

Step 2: Using a compass, make 4 circles of 7.5cm, 7.3cm, 4.3cm and 4.1cm radius.

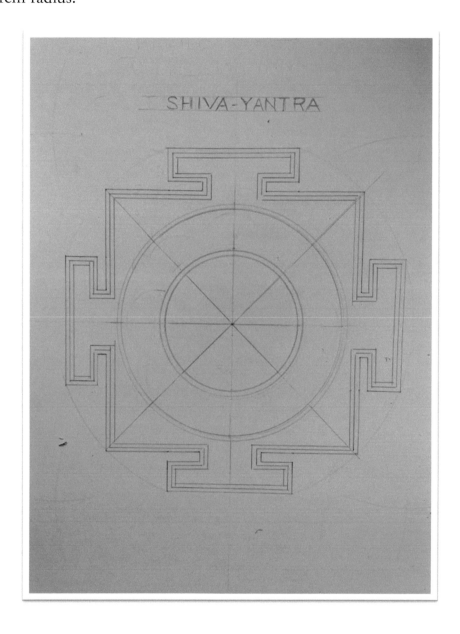

Step 3: Using a compass, draw semi-circles of 2cm radius on each of the points where the dividing lines cross the 4.3cm circle.

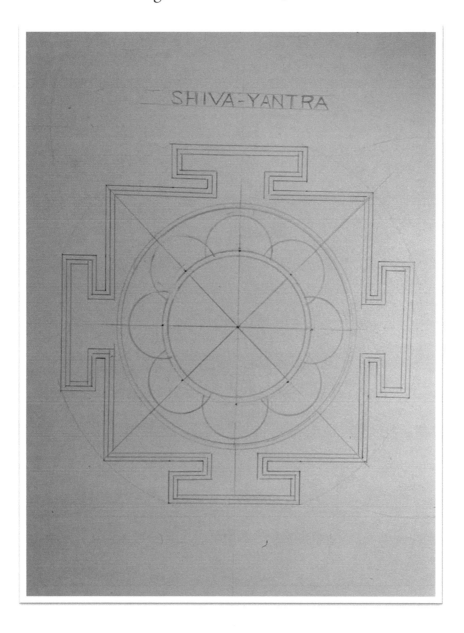

Step 4: Using the semi-circles to guide you, create lotus petals. You may refer to Vishnu Yantra chapter earlier for detailed instructions of how to make these petals.

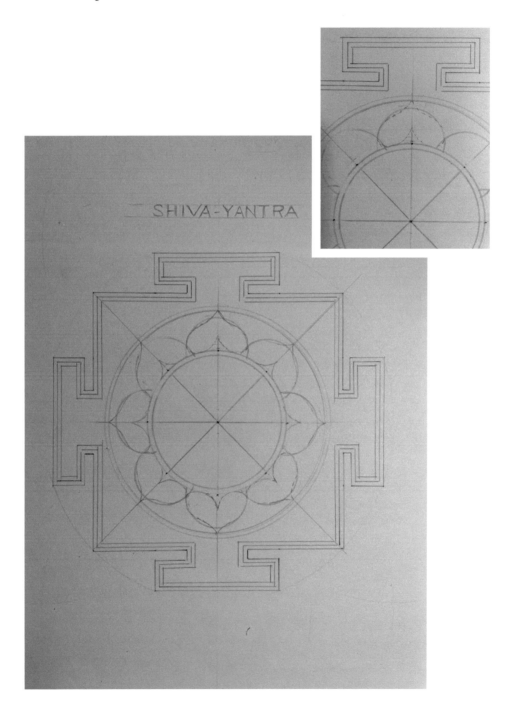

Step 5: Using a compass, place the pointer on the South point of the innermost circle and then open up the compass up to the soul dot. Now swing your compass left and right and mark the points on the inner circle on left and right. Join these points in a straight line.

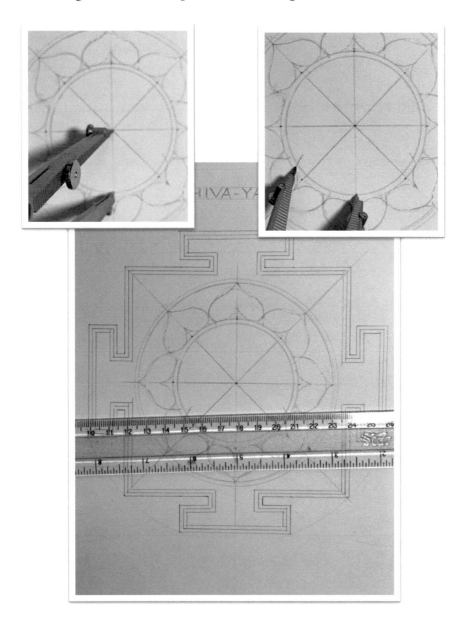

Step 6: Connect the end of the line you drew in the previous step to the North point of the circle to create a triangle.

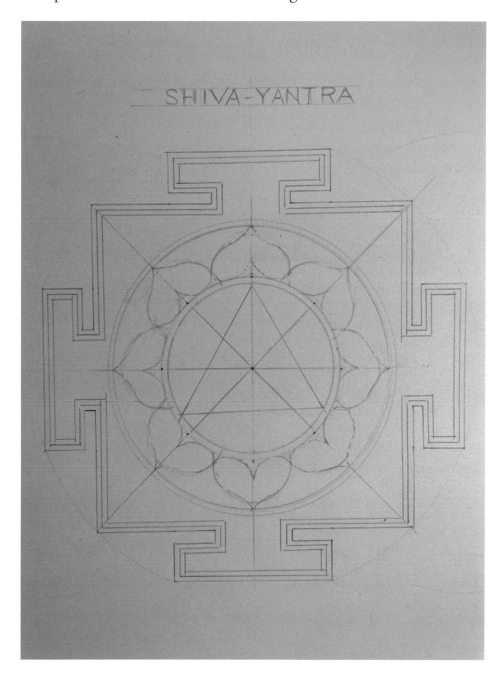

Step 7: Repeat step 5 from the North point of the innermost circle. However, do not connect the points you mark fully but instead leave a gap where the Shiva triangle overlaps.

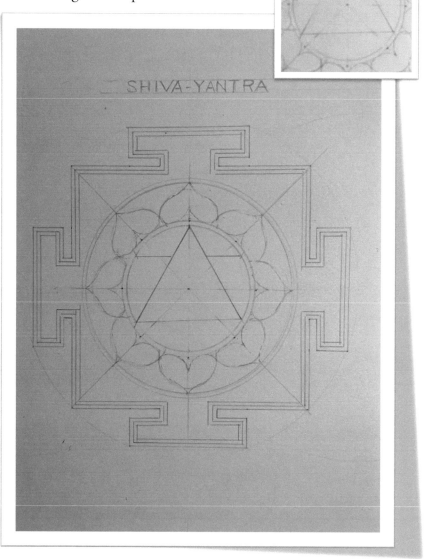

Step 8: Connect the points you marked in the previous step to the South point of the innermost circle but leave gaps where the Shiva triangle overlaps.

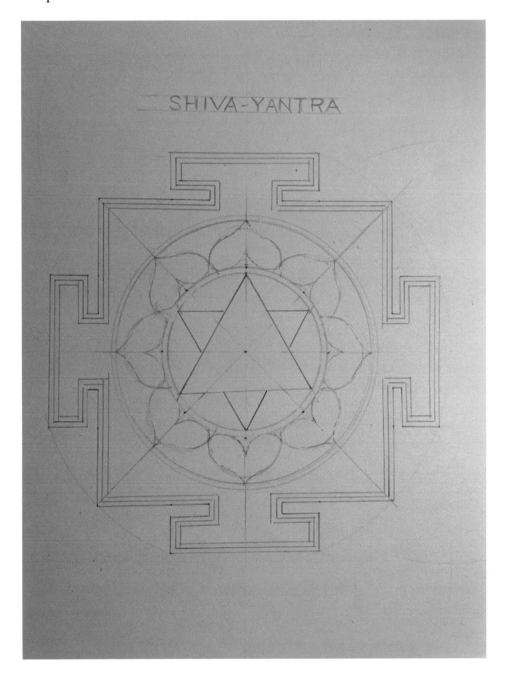

Step 7: Double the lines of the Shiva and Shakti triangles at 2mm gap.

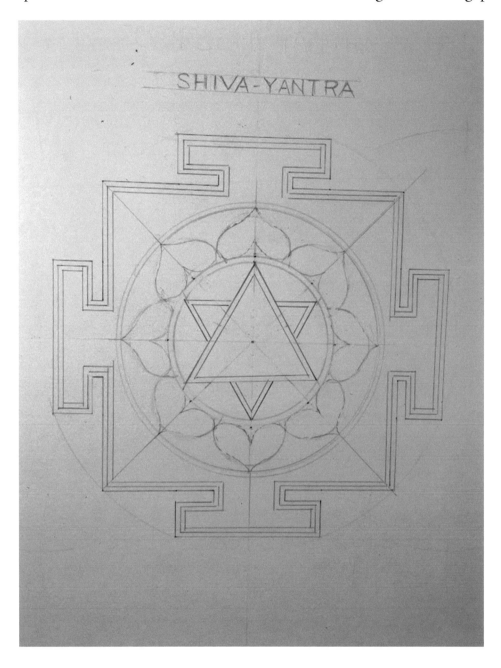

Step 8: Using a compass, place the pointer on the North point of the outer Shiva triangle. Open up the compass up to the soul dot. Using this as a measurement, swing compass to right and left and mark points on the inner Shiva triangle.

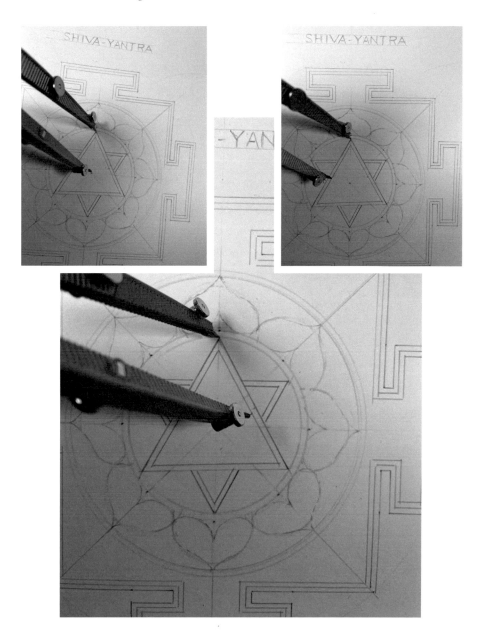

Step 9: Connect the points you marked in the previous step to the point where the vertical line crosses the inner Shiva triangle.

In addition, circle the soul dot. Your Shiva Yantra is ready for colouring.

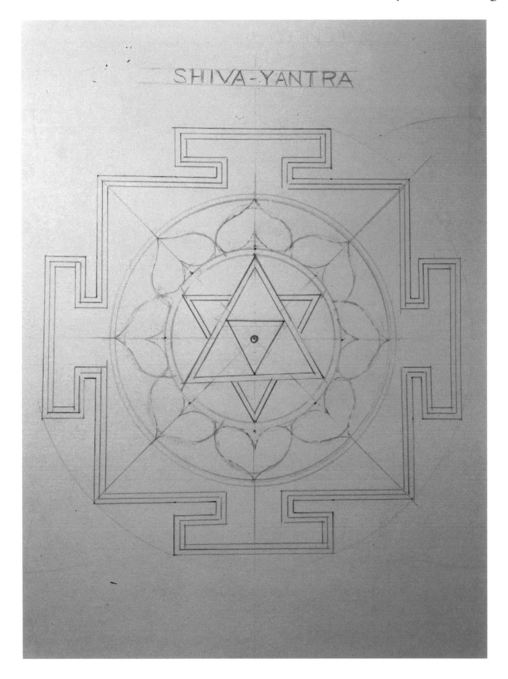

Colouring the Shiva Yantra

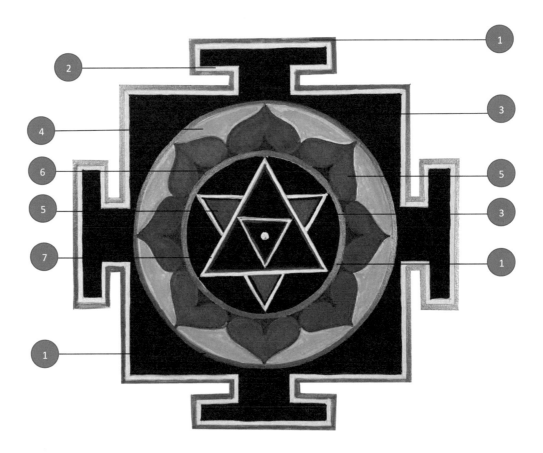

1. Gold
2. Lemon Yellow
3. Black
4. Cerulean Blue
5. Vermillion Red
6. Petal base – Burnt Sienna with Vermillion Red
7. White

Thank you

Thank you for choosing this book to help with your Yantra making practice. I hope you found the content useful and helpful.

Each Yantra is specific to the energy that it invokes and the deity it represents.

This book is the first in the series of books that includes detailed instructions on how to create a Yantra and how the Yantra benefits us.

Further volumes of this series include:

- Planetary Yantras
- Nine Goddess Yantras
- Dasham Mahavidya Yantras
- Distinctive Yantras

Enjoy your Yantra practice and remember that this should not be just a one-off activity but a lifelong practice to reap the full benefits of Yantra making.

About the Author

Born in a highly educated and spiritual family, Sushma was trained in art from a very young age.

Although Sushma's father was a senior magistrate by profession, he was also a gifted astrologer who even predicted the day of his death in a letter to his wife. He passed his gift and immense wisdom to his eldest son, Harish Johari who spread this knowledge globally.

Harish Johari was India's most well-known astrologer, tantric, spiritual author and teacher and his book on Ayurveda, Astrology and Spiritual Art

form the curriculum of many Yoga and wellbeing institutions. More information about him is available on sanatansociety.org which is still maintained by his family and followers worldwide.

Sushma completed her Masters in Visual Arts and got married and then subsequently moved to London and spent much of her life devoted to raising her children, decorating her beautiful home with her artistic talents and preserving the cultural values in them.

It's only after she freed herself of all her duties towards her children and grandchildren that she picked up her brush again and created paintings and sculptures of Indian deities. Other than being visually delightful, what made Sushma's artwork distinctive is her ability to share the story

and the valuable lessons that can be drawn from these visuals of Indian mythology. Sushma realized just how little people knew about the connection of the ancient stories with modern day lives and ultimately the science of our mind, values and body.

Sushma then embarked upon her mission of sharing the wisdom that was in her DNA with the world, through her art. Sushma has since then created an exclusive collection of paintings titled "Ancient beliefs or Science?" which was showcased at the Nehru Centre, London (Cultural wing of High Commission of India) in July 2019.

Sushma believes that people often confuse religion with spirituality. Religion gives you a set of rules and restrictions through which to lead a blessed life, whereas spirituality sets you free and allows you to make your own journey with your own rules.

Religion is a prescribed path through which we can gain the ultimate wisdom, however what mostly happens is people preserve the ancient traditions and stories and follow them rigidly, without embracing the implicit spiritual messages behind those ancient customs and why those customs were created in the first place.

Sushma has published two books on the relevance of the nine goddesses and the significance of the tradition of celebrating Navratri, which is probably the only Hindu festival that occurs twice in a year.

Sushma now gives talks on the meaning and benefits of spiritual art and also teaches yantra making to her students worldwide via online classes.

Made in United States
Troutdale, OR
03/02/2024

18126311R00098